A HISTORY OF
⇢JEWISH⇠
CONNECTICUT

A HISTORY OF

⇥JEWISH⇤
CONNECTICUT

MENSCHES, MIGRANTS AND MITZVAHS

EDITED BY BETTY N. HOFFMAN

Charleston ‖H‖ London

THE
History
PRESS

Published by The History Press
Charleston, SC 29403
www.historypress.net

Copyright © 2010 by Betty N. Hoffman
All rights reserved
Back cover, top middle: Louis "Kid" Kaplan.
Courtesy of Rosanne Kaplan Dolinksy.
First published 2010

Manufactured in the United States

ISBN 978.1.59629.987.0

A history of Jewish Connecticut : mensches, migrants and mitzvahs / edited by Betty N. Hoffman.
p. cm.
Includes bibliographical references and index.
ISBN 978-1-59629-987-0
1. Jews--Connecticut--History. 2. Jews--Connecticut--Social conditions. 3. Connecticut--Ethnic relations. I. Hoffman, Betty N.
F105.J5H57 2010
974.6'004924--dc22
2010039247

CONTENTS

Foreword, by Estelle Kafer 9
Preface 11
An Overview of Connecticut Jewish History 13

ESTABLISHING THE MODERN JEWISH COMMUNITY
Civil Rights of Jews in Connecticut, by Judge Henry S. Cohn 21
Historical and Architectural Survey of Historic Connecticut
 Synagogues, by David F. Ranson 24
Credit with a Little Schnapps, by Shelly Berman, PhD 29
Mount Sinai: Connecticut's Only Jewish Hospital,
 by Leon Chameides, MD 32

THE PEOPLE OF CENTRAL CONNECTICUT
Honesty, Courtesy and Service: The G. Fox Family,
 by Cynthia Harbeson 37
From the Civil War to Ados Israel: The Holtz Family,
 by Leonard Holtz 39
Annie Fisher: Educator, Administrator and Social Activist,
 by Betty N. Hoffman 41

CONTENTS

Craftsman Extraordinaire: Nathan Margolis and His Furniture,
by Eileen Pollack ... 43

Kid Kaplan: The Meriden Buzz Saw, by David Kluczwski 47

Marlow's for Everything: George Marlow and His Store,
by Bruce A. Marlow .. 50

Abraham Ribicoff: Connecticut's Only Jewish Governor,
an autobiographical sketch ... 54

Middletown's Hidden Treasure: The Shapiro Family Museum,
by Stephen P. Shapiro ... 57

"We Fell in Love with This Country," by Nadia Rivkin,
as told to Betty N. Hoffman 61

**FROM THE REVOLUTIONARY WAR TO JEWISH RENEWAL:
WESTERN CONNECTICUT**

Jewish Fairfield County: The Early Years, by Linda Baulsir,
with Irwin and Vivian Miller 65

Yes, There are Jews in Torrington, by Joyce Peck 70

Healer and Humanitarian, by Jacob Nemoitin, MD,
as told to Ronald Marcus .. 74

What We Did for Fun: A Conversation about Bridgeport,
as told to Betty N. Hoffman and Diane K. Cohen 77

The Isabella Freedman Jewish Retreat Center,
by Avital Rech and Barbara Starr 80

Danbury's Lake Waubeeka, by Cindy Mindell 85

A UNIQUELY CHANGING COMMUNITY: WATERBURY

They Found Their Way: Generations of Jewish Life in Waterbury,
by Mattatuck Museum ... 89

Transition: Revitalizing the Community, by Rabbi Judah Harris,
as told to Adam M. Shery .. 94

Yeshiva Ateres Shmuel of Waterbury, by Rabbi Aaron Sapirman,
as told to Betty N. Hoffman 97

CONTENTS

NEW HAVEN: YIDDISH AND YALE

Town and Gown Connections, by Dr. Barry E. Herman 101

Selma B. Rosenthal's Midwife's Ledger, by Dr. Barry E. Herman 106

Bagelizing America: The Lender Family, by Andrew Horowitz 107

Kruger's Juvenile Furniture, by Harry Kruger 110

TOWN AND COUNTRY: EASTERN CONNECTICUT

New London and Norwich, by Jerry Fischer 115

Connecticut's Jewish Farmers, by Mary M. Donohue and
 Briann G. Greenfield, PhD 121

"But Singing, He Comes Home," by Rabbi Debra S. Cantor 127

Chesterfield: A Shtetl in America, by Micki Savin 131

Between Marjorie Morningstar and Dirty Dancing:
 Grand Lake Lodge, by Marcia E. Tannenbaum 135

CONNECTICUT'S CONNECTION TO THE HOLOCAUST

From Nazi Germany to Hartford: One Family's Journey,
 by Shira Springer 139

Hiram Bingham IV: He Defied His Government to Save Lives,
 by Robert Kim Bingham Sr. 143

A New Life in New Haven, by Sally Horwitz 147

Conclusion 151

Bibliography 153

Index 155

About the Editor 159

FOREWORD

The Jewish Historical Society of Greater Hartford is proud to be a partner in the publication of *A History of Jewish Connecticut: Mensches, Migrants and Mitzvahs*. The Society is a nonprofit organization dedicated to collecting, preserving and exhibiting historical, political, economic, social and religious documents, photographs, memorabilia and oral histories as they relate to the Jewish community of Greater Hartford. By providing historical information and resources to researchers, educational institutions and civic and social organizations, the Society hopes to promote historical research and create community awareness and an understanding of the contributions Jews have made to Hartford's growth and development.

The Society archives contain files of synagogues, educational and communal organizations and institutions, the Jewish War Veterans archives, family papers, businesses, periodicals, scrapbooks, artifacts and more than eight hundred oral histories.

Most recently, we have created an exhibit on the life of one of Hartford's most famous Jewish natives, entertainer Sophie Tucker; published a collection of memories, *Remembering the Old Neighborhood: Stories from Hartford's North End*; and produced a documentary film, *Pride, Honor and Courage: Jewish Women Remember World War II*. In addition, we encourage families to preserve their own stories through oral histories

and memoir writing and have sponsored a Family History Day program with speakers and information on how to do genealogical research.

Estelle Kafer
Executive Director
Jewish Historical Society of Greater Hartford

PREFACE

When I first began thinking about Connecticut Jewish history, I visualized writing a chronology interspersed with interesting vignettes illustrating the various aspects of the Jewish experience. However, as I began my research, I found that some communities followed similar historical patterns, with stories that repeated in all but the details, while others were vastly different and did not fall neatly into this outline. My compromise was to write a general overview of the past 350 years to create a context for the following essays, which, I believe, shed light on the people and landmarks of Connecticut from a variety of perspectives.

As is always the case when delving into local history, as people learned about my project, they began to contact me with fascinating stories about additional people and places. Unfortunately, because of space limitations, I was not able to include as many of these as I would have liked. Nothing makes me sadder than typing "The End" when I know that I am only at the beginning. Clearly, every part of the state has a rich Jewish history, and I can only hope that historians, anthropologists and other knowledgeable individuals will create books, articles and exhibitions that tell the stories of their regions' vibrant Jewish history.

In the first section of this book, "Establishing the Modern Jewish Community," four authors discuss how Jews developed community and

became full citizens of Connecticut. "The People of Central Connecticut" tells the stories of a number of individuals and families who contributed to their Jewish communities in a variety of ways.

"From the Revolutionary War to Jewish Renewal" illustrates the diversity of Jewish life in western Connecticut since the colonial period. Although early Waterbury followed the more common pattern of Jewish urban/suburban development, it diverged in 2000 with a new Orthodox yeshiva repopulating the old Jewish neighborhoods. And New Haven, with its multifaceted connection to Yale, is unique in its own way.

Few remember—or even knew about—the Jewish farmers and the summer resorts of the last century in southeastern Connecticut. Finally, "Connecticut's Connection to the Holocaust" tells the little-known stories of two Christian rescuers and several survivors.

For assistance with this project, I would like to thank the contributors—each with his or her distinctive voice—listed in the contents who were so generous with their expertise. Members of the of the Jewish Historical Society of New Haven (JHSNH), Marvin Barger, Barry Herman, Werner Hirsch and Rhoda Zahler, and the Jewish Historical Society of Lower Fairfield County (JHS/LFC), Irwin and Vivian Miller and Linda Baulsir, were helpful throughout the process of putting this book together.

In addition, the following people loaned photographs and old postcards, helped with arrangements or answered my endless questions: Shelley Berman, Jon Chase, Diane Cohen, Rosanne Kaplan Dolinsky, Suzie Fateh, Rob Feder, Marie Galbraith, Joan Marlow Golan, Georgia Haken, Jennifer Levin-Tavares, Lillian Marlow, Peggy Mendelson, Carol O'Shea, Mimi Perl, Karen Senich, Helene Springer, Elizabeth Van Tuyl and Izzy Weinreb.

As always, I am grateful for the sponsorship of the Jewish Historical Society of Greater Hartford (JHSGH) under the direction of Estelle Kafer and her staff, Bea Brodie and Cynthia Harbeson.

Finally, thank you to my family, my greatest cheerleaders. In particular, Elana proofread the manuscript and learned to use a camera so that she could photograph whatever I needed. My husband, Herbert Hoffman, has been my long-term support in every way.

Thank you all. Without you there would not have been a book.

AN OVERVIEW OF
CONNECTICUT JEWISH HISTORY

Although the great majority of European Jews immigrated to Connecticut and settled in its cities between 1880 and the closing of the doors to immigration in the mid-1920s, other Jews came at different times and had different experiences.

In its earliest years, Connecticut did not welcome Jews or, indeed, most Christians. Reverend Thomas Hooker, who led an early group of English settlers to Connecticut in the 1630s, established the Congregational Church as the only religious body in the new colony. For nearly two centuries, Congregationalists wielded enormous power over the religious, political and social life of Connecticut.

The first Jew in recorded Connecticut history was an itinerate peddler, David the Jew, cited in the Hartford Court Records of 1659. Most likely, David was part of the Sephardic Jewish community of New Amsterdam. Other Jews mentioned in the early Connecticut records—unnamed men living in John Marsh's house in Hartford (1661); Jacob the Jew, a horse trader (1667); and Jacob Lucena, a peddler (1670)—were probably also Sephardic transients. If they remained, they did not form permanent communities but blended into mainstream life, leaving their Jewish heritage behind.

Jewish peddlers continued to travel throughout Connecticut during the eighteenth century. In the 1770s, during the Revolution, several

families fled from the British occupations of Newport, Rhode Island, and New York, where there were relatively sizeable Jewish communities. Most took refuge in Fairfield County but returned to their homes when hostilities ceased.

It was not until the early nineteenth century that a few Jews began to filter into Connecticut towns where they opened businesses. Branford, Norwalk, Hartford, New Haven, Stamford and Woodstock all had "Jew Streets" in their commercial districts.

Beginning in the 1830s, a large wave of German-speaking immigrants, fleeing political and economic hardship, came to America. Among them were Jews who—within a short time—outnumbered their Sephardic predecessors. Wherever they settled in Connecticut, the German Jews adapted rapidly to American life. At first, the Jews, who were forbidden by law to organize formal congregations, worshiped in private homes. It was

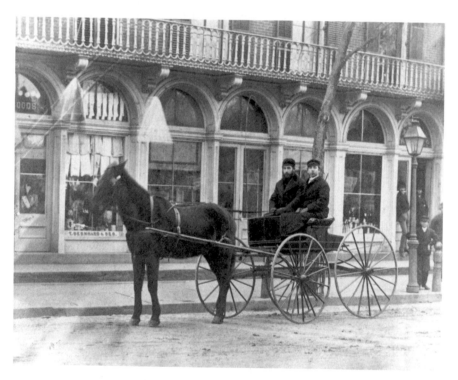

Tobias and Henry Bernard in front of their millinery and fancy goods store in Stamford, circa 1869. *Courtesy JHS/LFC.*

not until 1843 that groups from Hartford and New Haven successfully petitioned to have the laws changed to allow them the same religious rights as Christians.

In the cities and small towns, Jewish life followed much the same pattern with a few families establishing homes and finding work—in a variety of jobs such as merchants, teachers, grocers, watch repairers and butchers—or starting businesses. They encouraged family and friends to join them, developed communities with religious, social and charitable organizations and began the process of becoming Americans. Overall, these German Jews created the basis for the modern Jewish communities of today.

On March 13, 1881, the assassination of the Russian tsar Alexander II altered the course of American Jewish history. False rumors that the Jews were responsible circulated throughout the country, instigating *pogroms* (murderous anti-Jewish riots) and the May Laws (restrictive legislation) that made Jewish life, already difficult, even more so.

At the same time, Jews in other Eastern European countries were also deciding that life anywhere else was better than in their homelands. For the next forty years, millions of Yiddish-speaking Jews left Eastern Europe, many determined to make new lives in *die goldene medine*, the Golden Land: America.

Enormous variety existed among the immigrants from Eastern Europe. They came with a wide range of economic skills, levels and types of education, political views and Jewish beliefs and behaviors. As a group, however, the immigrants were poor, and many needed help from the established community.

In 1881, when New Haven Jews founded the Hebrew Benevolent Society to assist refugees from Russia, they had no idea that within a few years the newcomers would outnumber them and change the Jewish composition of the city. In Hartford alone, the Jewish population rose from fifteen hundred in 1880 to eighteen thousand in 1920.

The immigrants moved into the cheap apartments in the downtown areas of Connecticut cities and towns where they mixed with other immigrants who were also striving to make new lives. Jewish farmers, however, did not settle in the cities but created enclaves in established Yankee farming communities in several parts of the state.

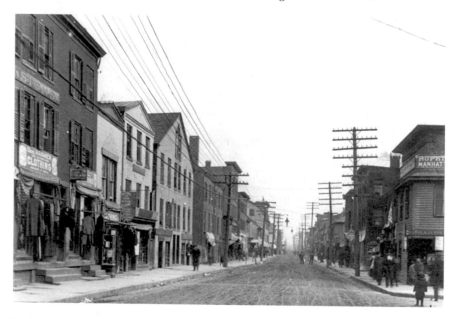

Front Street on Hartford's Jewish East Side. *Courtesy JHSGH.*

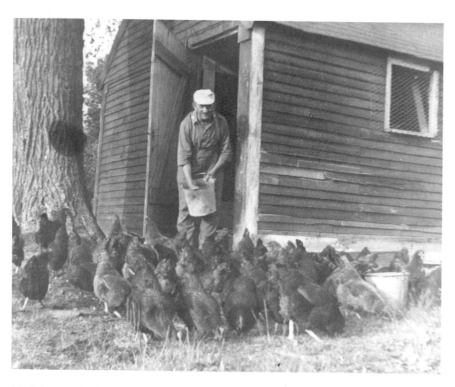

Mr. Schwartz, feeding chickens on his farm in Lebanon. *Courtesy JHSGH.*

Accustomed to maintaining their own religious schools and synagogues and providing for the poor and sick within their former communities, the newcomers founded a dense network of religious, charitable, recreational and social organizations that reflected the practices of their home countries and were generally separate from the institutions established by the German Jews

Beginning in 1914, World War I virtually halted Jewish immigration for four years. Afterward, immigration soared, bringing the national Jewish population to an estimated 3.5 million. This ended in the mid-1920s when Congress passed the Immigration Restriction Acts.

Until that time, many Jews were consumed with the dual need to bring their families from Europe and to build new Jewish lives for themselves in America. With immigration quotas strictly enforced, the main task of American Jews became developing their own communities. Even so, many continued to aid relatives abroad and to work toward founding a Jewish national home in Palestine.

During this period, many Jews moved out of the areas of first settlement in the cities into more comfortable accommodations. They built more elaborate synagogues in the new neighborhoods, expanded or created Jewish communal institutions and participated in an enormous variety of organizations.

While anti-Semitism may have been unpleasant in Connecticut—as it was elsewhere in the United States—it never reached the sustained, violent levels that many immigrants had experienced in Europe. Everyone knew that children shouted ethnic slurs and fought one another and that some neighborhoods did not permit Jews. They were also aware of the exclusionary hiring practices in some companies and of college quotas limiting the number of Jewish students. Nevertheless, with America offering so many paths to success, many Jews avoided the restrictions and created satisfactory lives in the Golden Land.

The most serious expression of anti-Semitism developed in the 1930s, when the federal government refused to relax its immigration policy to admit large numbers of refugees from Nazi oppression and murder. However, a relatively small number were granted lifesaving visas.

After the war, Jewish organizations lobbied Congress to admit the refugees. By 1952, more than 137,000 Jewish displaced persons had

arrived in the United States. Aided by the precursor of the current Jewish Family Services of Greater Hartford, approximately 500 of these, most with relatives in the region, settled in central Connecticut.

As part of a nationwide postwar trend, Jewish soldiers returning to Connecticut were eager to move beyond the old ethnic neighborhoods. Many took advantage of government grants for further education to increase their earning potential. Throughout America, new roads, funded by the government, opened suburbs to new construction, and former soldiers used government benefits to buy houses.

As large numbers of Jewish families moved out of the cities, the synagogues, the community agencies and the organizations began to follow their members. This exodus restructured the way Jews related to their synagogues and to their communities, which were no longer as compact and dense as they had been.

From the beginning, most American Jewish children attended public schools. Those families who chose to give their children religious educations generally sent them to supplementary religious programs, frequently associated with synagogues. By the mid-twentieth century, this began to change as some groups began working toward providing more extensive Jewish educations for their children.

In the mid-1960s, Congress created new immigration legislation, which, as part of the larger picture, favored refugees from Communism. At the same time, conditions for Jews in the Soviet Union were deteriorating, and many were determined to leave despite the obstacles initiated by the Soviet government.

Within ten years, the first families of Russian Jews, as they were popularly and erroneously called, arrived in the United States. In Connecticut, as in the rest of the country, an enormous Jewish community effort—funded by a combination of federal refugee grants and Jewish charitable funds and facilitated by the Jewish Federations and their affiliated agencies—assisted with every aspect of their resettlement.

This wave of immigration, which lasted until the end of the century, brought approximately 700,000 Jewish refugees to the United States. Just how many settled in each location is a matter of conjecture, but the estimate for Greater Hartford is between 1,500 and 2,000.

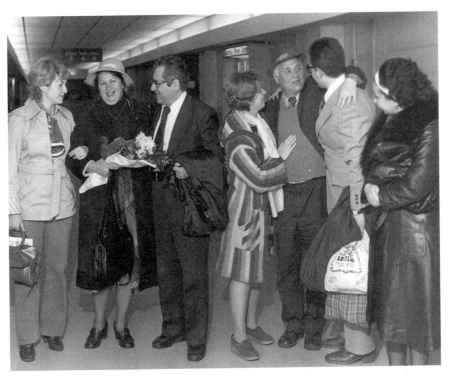

Refugees from the Soviet Union at Bradley Airport, circa late 1970s. *Courtesy JHSNH.*

During the past century and a half, Connecticut Jews as a group have been politically active both as voters and in public office, primarily as Democrats. While the majority have served at the state and local levels, a few have gone on to national prominence, among them Abraham A. Ribicoff, Connecticut's only Jewish governor. Joseph I. Lieberman was the first Jew to run for vice president—with unsuccessful Democratic presidential candidate Al Gore in 2000—on a major ticket. Clearly, Jews have come a long way since their first foray into Connecticut politics—petitioning the state in 1843 to allow them to form legal houses of worship.

Establishing the Modern Jewish Community

Civil Rights of Jews in Connecticut

Judge Henry S. Cohn

The status of Jews in Connecticut from the founding of the colony in 1636 to the early 1800s was decidedly mixed. As an example of this ambivalence, in November 1818, the *Hartford Courant* reprinted a news article from the *Boston Recorder*. In announcing a mission to the Holy Land, the author declared that "[w]e alone of all the nations of the earth can stand up and say that we have never been engaged in persecuting the Jews. Among us the children of Israel have the same rights and privileges as those of us who are Gentiles." Yet a follow-up article, written by the director of the mission in December 1820, states: "With respect to the Jews, it has not been in our power as yet to extend to them the hand of benevolence...[They] are fortifying themselves in their infidelity." Other *Courant* articles from this time tell of Jews who had "seen the light" and converted to Christianity.

The first point to be made in discussing relations between the Jews and Connecticut authorities is that there were hardly any Jews (one politician in a speech in 1818 said none at all) in Connecticut before 1818. Only "David the Jew" and "Jacob the Jew," having received permission from

the town meeting to reside in Hartford in the late 1600s, appear in the public record.

Both David and Jacob were sanctioned for violations of city ordinances while conducting their businesses. David was fined for approaching dwellings where the head of the family was absent. Jacob was tried and found guilty of "dalliance" with "several women." His initial fine of ten pounds was eventually set aside, after a prominent New York Jew traveled to Hartford and spoke in his favor. Such restrictions on settlement and police regulation of their businesses hardly encouraged Jews to choose residence in Connecticut.

Also affecting both the number of Jews and their efforts to organize worship in Connecticut was the domination of the Protestant Congregationalists. Connecticut was founded by a separatist branch of the Puritans who arrived in Massachusetts in 1620. They had great devotion to the Old Testament. Thomas Hooker, their leader, spoke eloquently of laws being enacted by the "free consent of the people."

But the Connecticut Puritans' beliefs only extended to the members of their church. In 1662, the royal charter, obtained from Charles II and drafted in Connecticut, only gave religious and political rights to the Congregationalists (the successors to the Puritans). In 1708, the General Assembly granted limited toleration to Anglicans, Quakers and Baptists (the so-called "dissenting churches"). In 1727, as a concession to the English Crown, Anglicans were permitted to build their own churches and hold services separately.

In 1791, after the Revolution, two statutes were passed to excuse dissenting church members from the requirement that they regularly attend Congregational services, so long as they went to their own churches. Writing in his *System of Laws* (1795), Zephaniah Swift, a prominent legal scholar and later Connecticut's chief justice, reasoned that the 1791 statutes also applied to "Jews, Mehometans, and Bramins" who may "practice all the rites and ceremonies of their religion, without interruption or danger of incurring punishment."

The Constitutional Convention of 1818 was convened to disestablish Connecticut's theocracy under the control of the Congregationalists. The delegates followed Judge Swift in adopting Article I, Section 3 of the 1818 constitution: "The exercise and enjoyment of religious

profession and worship, without discrimination, shall forever be free to all persons in this state." As delegate Treadwell declared: "[A]ll sects of religion should be tolerated in the State." He had no objection to Section 3, but was "willing there should be universal toleration. Papists, Mahommedans, Jews, or Hindoos, should be allowed to meet together and tolerated."

The delegates did change proposed Article I, Section 4, however. It originally read that "[n]o preference shall be given to any religious sect, or mode of worship." Delegates Treadwell and Edwards successfully changed this wording, after a debate in which delegates Wolcott and Morse opposed the change, by substituting the word "Christian" for "religious." The change was made to emphasize the preferred position of the Christian religion. Neither the 1818 constitution nor any statute of that date allowed for organized Jewish assembly.

After the 1830s, as the Jewish population increased, prominent Connecticut Jews pressed the legislature to change Article I, Section 4. In 1843, the General Assembly, however, resolved the rights of Jews by a statute providing that "Jews who may desire to unite, and form religious societies, shall have the same rights, powers, and privileges, as are given to Christians of every denomination by the laws of this state." Similar legislation was enacted at this time in Maryland, Rhode Island and New Jersey.

It was not until 1843 that a minyan (a group of at least ten Jewish men) that began in New Haven in 1840 and a second minyan in Hartford became Connecticut's first Jewish formal congregations, Mishkan Israel and Beth Israel, respectively.

The United States Constitution's First Amendment, "free exercise" clause made the Connecticut 1818 language favoring Christianity obsolete. The First Amendment applied to the states after the Civil War with the adoption of the Fourteenth Amendment in 1868.

However, Article I, Section 4, of the 1818 Connecticut Constitution was not deleted until the adoption of the 1965 Connecticut Constitution, in effect today. Article I, Section 3 of the 1965 constitution provides:

The exercise and enjoyment of religious profession and worship, without discrimination, shall forever be free to all persons in the state; provided

that the right herein declared and established, shall not be so construed as to excuse acts of licentiousness, or to justify practices inconsistent with the peace and safety of the state.

Connecticut Superior Court judge HENRY S. COHN *has written a number of articles on Connecticut history, as well as a book on the legal aspects of the Hartford Circus Fire of 1944 with coauthor David Bollier (Yale University Press).*

HISTORICAL AND ARCHITECTURAL SURVEY OF HISTORIC CONNECTICUT SYNAGOGUES

David F. Ranson, Architectural Historian, Connecticut Historical Commission, 1991

Introduction by Betty N. Hoffman

In 1856, after years of holding services in members' homes and rented spaces, the members of the first two German-Jewish congregations in Connecticut—Congregation Beth Israel in Hartford and Temple Mishkan Israel in New Haven—purchased their first buildings using funds donated by the philanthropist Judah Touro. Beth Israel bought the First Baptist Church and Mishkan Israel, the Third Congregational Church, both of which served their communities until the members could afford to construct buildings specifically designed to be synagogues.

The new buildings, Beth Israel (1876) on Charter Oak Avenue and Mishkan Israel (1895) on the corner of Orange and Audubon Streets, reflected the development of their communities, which were in the process of modernizing and adopting American Reform Jewish practices. Both congregations had come a long way from their immigrant beginnings and were determined to build substantial structures that illustrated this progress. Years later, the synagogues followed their congregations to the suburbs, with Beth Israel building in West Hartford in 1936 and Mishkan Israel in Hamden in 1960.

Congregation Beth Israel

Temple Beth Israel is significant architecturally because it is the first building to be constructed in Connecticut for use as a synagogue. It was designed by George Keller, Hartford's leading nineteenth-century architect, to resemble prominent Reform temples in Berlin and New York City. Completed at a cost of $35,567, the new temple was dedicated on May 26, 1876, when the congregation had a membership of seventy-eight.

Temple Beth Israel is located half a block east of Main Street, facing north. Sited off center to the east on its 94- by 135-foot plot, the temple is a 56- by 90-foot rectangular red brick building. The overall design is High Victorian Eclectic with major elements drawn from Romanesque architecture.

The façade is dominated by two square corner towers, capped with octagonal domes. Between them the central composition features an

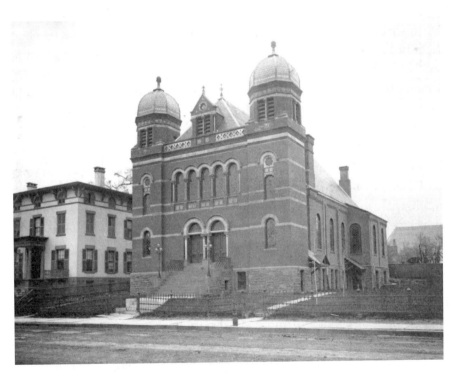

Congregation Beth Israel on Charter Oak Avenue, the first synagogue constructed for that purpose in Connecticut, dedicated 1876. *Courtesy JHSGH.*

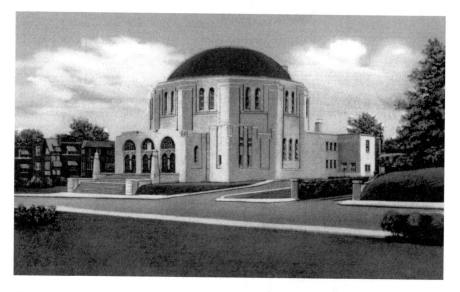

The first synagogue to move to Hartford's suburbs, 1936. *Courtesy JHSGH.*

entrance of two heavy double wooden doors six feet above grade, reached by a broad flight of brownstone steps. Above the entrance is an arcade of five round-arched windows. Both the entrance and the windows are framed by stone columns with foliated capitals and molded brownstone arches. The center of the roofline is broken by a gabled dormer that projects from a truncated slope of the gable roof.

The side elevations have brick round-arched windows set in panels between pilasters that support corbelled eaves. Originally, these windows had leaded glass in a diamond pattern, but this glazing, which was appropriate to the overall design, has been replaced with rectangular panes in wooden muntins under fanlights that gave a Georgian Revival effect.

The large open interior seats six hundred people in plain wooden pews. At the front is the recessed space for the ark and three stained-glass windows; the central round-arched window shows the Decalogue, while the flanking windows are quatrefoil shaped. Engaged columns with foliate capitals similar to those on the front elevation support a blind arcade of three round arches under the windows. How this arrangement worked with the Tiffany ark enframement now at Temple Beth Israel in West Hartford is not certain.

Originally, the width of the nave diminished behind the towers. In 1899, the seating capacity was increased by moving the walls of the nave almost to the line of the towers. The original walls were replaced with arches supported by cast-iron columns. At each column there is a wooden bracket to support the new outboard roof section. The interior was elaborately stenciled in a colorful mix of buff, blue and chocolate at the time.

Temple Mishkan Israel

Temple Mishkan Israel is a sophisticated example of traditional Connecticut historic synagogue urban architecture, perhaps the finest in the state, and it was the first structure of importance to be erected by New Haven's Jewish community. The basic plan of a recessed central section with a triple entrance flanked by projecting towers under the domes was executed by Brunner & Tyrone of New York City with great elaboration yet also with great restraint. The decorative features are controlled in a scale that adds to the overall architectural effect rather than overwhelming the design. The building cost $73,642.

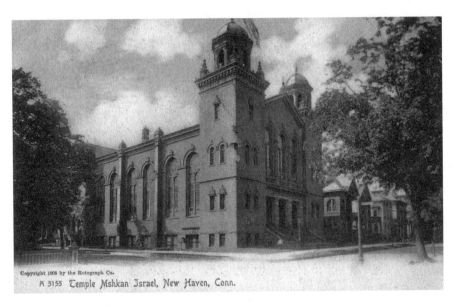

Copyright 1905 by the Rotograph Co.
A 3155 Temple Mshkan Israel, New Haven, Conn.

Courtesy Miskhan Israel.

Mishkan Israel's modern sanctuary in Hamden, 1960. *Courtesy Miskhan Israel.*

In the temple's brick façade, broad steps lead up to a triple entrance under round-arched windows between projecting towers. The entranceways are divided by square piers rather than round columns, and there is an elaborate anthemia pattern in the wide brownstone frieze supported by the piers. The three tall windows over the entrance rise above balustrades. The pilasters between them have Corinthian capitals. In their three round arches, molded archivolts are recessed behind an embellished band in which a carved console keystone is centered.

The horizontal line of the entrance cornice is extended around the towers by a molded stringcourse. Below the stringcourse there are two trabeated windows at the first floor. The jambs of the windows and the corners of the towers are quoined. The first-floor windows are capped with intricately carved brownstone shields or crests. At the second floor, the paired windows are round arched under dripstones with flaming-urn finials. A single first-floor window is repeated at the third floor. The tower roofline entablatures are elaborate, consisting of paneled frieze and two-tiered modillion course and projecting cornice with egg and dart molding at its edge. Vigorous finials rise from the corners of

the towers, setting off the central arcade drums that support six-sided copper domes.

The sanctuary was formerly a Renaissance Revival space focused on a great round-arched stained-glass window in the west wall. A paneled apse-like enclosure for the ark was centered in a paneled half wall in front of the window. Candelabra symbolic of the menorah of the Temple of David flanked the ark. At the top of the wall, a balustrade, similar to those on the façade, defined a half-round pediment in which a Decalogue was centered. The round arc of the great window was carried into the room by a barrel-vaulted ceiling supported on each side by two colossal veined-marble columns. Seating, which included a balcony across the rear, accommodated nine hundred people.

Excerpted from "1843–1943: One Hundred Years of Jewish Congregations in Connecticut: An Architectural Survey: 5603-5703," Connecticut Jewish History 2, no. 1 (Fall 1991). Additional research materials provided courtesy of the Connecticut Commission on Culture & Tourism.

CREDIT WITH A LITTLE SCHNAPPS

Shelly Berman, PhD

The late nineteenth and early twentieth centuries brought about enormous changes in America's credit needs. A burgeoning population combined with the uprooting of millions of rural folk to America's urban settings meant that the usual forms of credit—reliance on family and friends—no longer fulfilled the nation's demands. Industrialization introduced a variety of consumer items on the market, necessitating new sources of funds to accommodate the material appetites of American households. Like other Americans, Jews sought funds to purchase consumer items, pay for fuel and meet expenses incurred during illness. In addition, Jews—an immigrant group that was overrepresented in small business—needed credit outlets to sustain their entrepreneurial ventures.

At a time when few credit options existed, ethnic loan societies provided East European immigrant Jews with critical sources of capital. Since

banks were not an available option for funds, American Jews created a network of loan societies that included credit cooperatives, as well as traditional Hebrew free loan societies often known as *hevrot gemilut hasadim*.

Beginning in the 1880s, East European Jewish immigrants transported Hebrew free loan societies—philanthropic associations organized around a biblical and Talmudic prohibition of charging interest to fellow Jews—from Europe to America. They raised capital from supporters' contributions and then loaned the funds without interest to borrowers who furnished the names of appropriate endorsers. The endorser system, predicated on mutual trust, proved so effective that most societies experienced an annual default rate of less than 1 percent. By 1927, more than five hundred societies existed in communities as diverse as Des Moines, Nashville, San Francisco and New York. In Connecticut, there were Hebrew free loan associations in Hartford, New Haven, New Britain and Waterbury.

Ethnic culture and religious tradition, however, did not limit immigrant loan activity. In addition to traditional free loan societies, American Jews organized modern credit cooperatives that charged interest on loans and, therefore, had no basis within Jewish law. Unlike the philanthropic Hebrew free loan societies that had two distinct classes of people—contributors who provided the loan capital and borrowers who made use of the funds—cooperative credit unions generated their loan capital from the borrowers themselves.

An organization did not become a credit union until it was legally incorporated under a state credit union law or, after 1934, under federal law. Many Jewish credit unions, however, had their origins as informal credit cooperatives known in Yiddish as aktsiyes. Aktsi has its etymological roots in *aktiengesellschaft*, the German word for a society of shareholders or joint stock company. The primary distinction between a credit union and an aktsi is that the former was government regulated while the latter had no legal status.

During the first decades of the twentieth century, experts on credit observed the widespread use of aktsiyes by Jews. Estimates of the annual amount loaned by aktsiyes during the 1920s and very early 1930s range from $50 million to $60 million, far greater than the amount loaned by Hebrew free loan societies. While more than 70 percent of this large

volume of capital was centered in New York, aktsiyes were also popular among Connecticut's Jews. According to Hyman Kurnitsky, a Hartford credit union leader, "In the labor lyceums, in synagogues, in homes, in basements, they had aktsiyes."

The secretary-treasurer of Connecticut's Mansfield Community Mutual Benefit Association described how his organization functioned: "At first we didn't charge interest rates. We worked off the kitchen table, nobody got salaries, there were no offices and no bonding, and it wasn't all that unusual for the treasurer to skip town with the assets in his pocket." Prompted by this concern that unlicensed cooperatives were mismanaged and had high rates of embezzlement, credit union activists sought to bring all cooperative loan societies, including aktsiyes, under state supervision.

Many people involved with aktsiyes, however, feared that aktsiyes would lose their Jewish character because once under government jurisdiction, they would not be allowed to deny non-Jews access to their institutions. If non-Jews joined their organizations, the economic function of the aktsiyes might not be threatened, but their social function would likely be transformed. For example, one former Connecticut aktsi member reminisces how "we would get together in somebody's home, get our business done and then we'd all have a little schnapps." In a 1976 article, "Oxies [Aktsiyes]— Symbol of a Fading Era," the *Courier*, Connecticut's credit union publication, describes the changes that occurred after regulation took place in the mid-1940s:

> Oxies [lost] *their specialized flavor of being exclusively Jewish and opened their doors to the larger community. They tightened up their operations, began to pay salaries, rented offices, and in modernizing gained a measure of security while forfeiting some of the old ethnic flavors that had made them as much a social organization as an economic cause.*

Jews were not the only immigrant group to create loan societies after they arrived in the United Sates. Pre–World War II Japanese and Chinese, who were also overrepresented in business, organized rotating credit associations based on models from their countries of origin. Without access to capital, neither Jewish nor Asian enterprises would

have survived. Therefore, by supplying immigrant entrepreneurs with funds to start and expand businesses, ethnic loan associations facilitated their rise up the economic ladder. Credit institutions such as aktsiyes were an important feature of a cohesive ethnic economy that bound members to one another as lenders and borrowers.

SHELLY BERMAN, PHD is professor of sociology and the coordinator of undergraduate activities for the Strassler Family Center for Holocaust and Genocide Studies at Clark University. Her publications include "Borrowers or Lenders Be: Jewish Immigrant Women's Credit Networks" in Pamela Nadell (ed.), American Jewish Women's History: A Reader *and* A Credit to Their Community: Jewish Loan Societies in the United States, 1880–1945.

MOUNT SINAI:
CONNECTICUT'S ONLY JEWISH HOSPITAL

Leon Chameides, MD

Mount Sinai Hospital began as a dream in 1917, became a reality in 1923 and was absorbed by St. Francis Hospital and Medical Center in the 1990s. Two threads run through its tapestry. One is the enormous dedication and effort made by the community, medical and nursing staff and hospital employees to build a hospital with a feeling of family and warmth. However, forces beyond their control made them face crisis after crisis until they were overwhelmed.

A series of meetings, held by a group of Jewish physicians and community leaders between 1916 and 1918, culminated with a letter from Moses Goldenthal to Mr. Haas, president of the United Jewish Charities, indicating that "there is something lacking in Hartford to supply the needs and gladden the hearts of its Jews"—namely, a hospital.

The group believed that such an endeavor was necessary because of the need for more hospitals in Hartford, the prejudice against Jewish physicians and lack of internship slots for them in the existing hospitals, the discomfort of Jewish patients in the other hospitals (and especially the lack of kosher food) and the need for a training school for nurses.

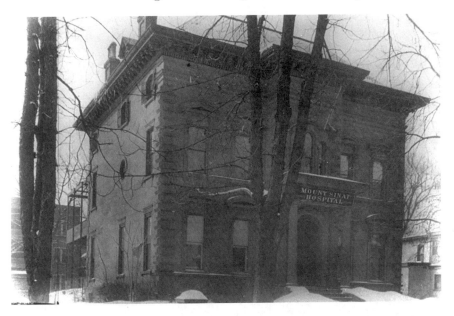

Mount Sinai Hospital on Capitol Avenue in Hartford, dedicated 1923. *Courtesy JHSGH.*

Hartford already boasted three hospitals: Hartford Hospital, St. Francis and a municipal hospital. Other communities had opened Jewish hospitals, and by 1925 there were seventy Jewish hospitals in the United States.

On March 16, 1918, the planning committee filed a certificate of incorporation for the establishment of the Abraham Jacobi Hospital, named after a prominent New York Jewish physician who became president of the New York Medical Society and was the first foreign-born physician to head the American Medical Association. The name was changed to Mount Sinai in April 1922.

On April 9, 1922, the board bought the Brainard Mansion at 119 Capitol Avenue for $62,500. The Ladies Auxiliary sewed curtains and bought furniture with proceeds of a fund drive with the slogan, "A Hospital for All." The fund drive raised $130,000 ($30,000 over its goal). Mount Sinai Hospital was dedicated on March 13, 1923, and officially opened on May 6 with seventy-five beds and two patients (Mr. Goldenthal's daughter, Mrs. Gross, gave birth the day before.)

The first year ended in crisis. The hospital had cared for 819 patients and 108 newborns at an average daily cost of $4.69 but ended the year

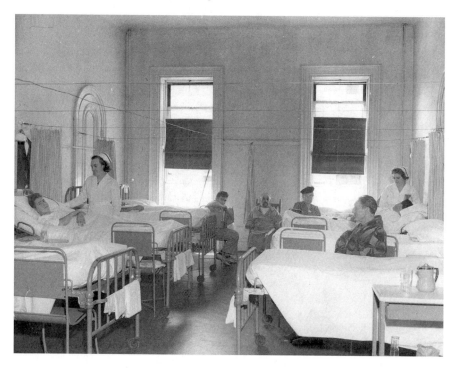

Mount Sinai Hospital Ward, 1923. *Courtesy JHSGH.*

with an $11,000.00 deficit and a realization that it was too small to survive. A School of Nursing opened in January 1925 but closed in 1934 because it could not meet the rising educational standards imposed by the state.

Fund drives had to be held to cover annual deficits, and by 1929, it was decided to build a new hospital. But a building fund drive was repeatedly delayed: first because of the economic depression and then the needs of Jewish refugees fleeing Europe. The drive, which finally began in 1940, had had broad community support with Judge A.S. Bordon as general chairman and A.I. Savin as advance gifts chairman. It netted over $200,000, but World War II forced postponement of construction until 1948. In the interval, construction costs had increased. A new fund drive, launched in 1945 under the leadership of A.I. Savin, Sol Kohn and Sam Suisman, netted $965,000. The same year, Dr. Isidore Geeter joined as executive director. Meanwhile, costs continued to rise, and so, in 1948, the Jewish Federation agreed to start a $2.5 million drive with the first $700,000 earmarked for Mount Sinai. The cornerstone for a new 115-

bed hospital was laid on November 18, 1948, on the Tower Avenue site of the former Hebrew Women's Home for Children. The hospital was dedicated on March 20, 1950.

During the long interval that passed between planning for a new building and its realization, medicine progressed rapidly. New therapies and diagnostic techniques were discovered, specialization was starting, hospitals became educational institutions, there was a population explosion, salaries rose rapidly and insurance coverage began. Mount Sinai had made no provisions for these changes and so, despite a new building, found itself short of space once again, with a growing annual deficit. An addition to the building was completed in 1960, increasing the number of beds to 189. The $1.9 million fund drive for the expansion showed that the hospital, 50 percent of whose patients were not Jewish, had become a community asset.

Once again, medical developments in full-time positions, specialization and new diagnostic tests and therapeutic modalities made additional space mandatory, and a 1961 long-range plan called for the expansion of the hospital to four hundred beds. No one at this time could have foreseen the massive migration of the Jewish community from the North End of Hartford to the suburbs, the effect of the new University of Connecticut School of Medicine, the drive for shorter lengths of stay, ambulatory surgery or the effect and power of medical insurance.

A fund drive for the expansion was launched in 1965 under the chairmanship of Richard Koopman and eventually raised almost $7 million, but the new hospital was not ready for occupancy until 1973. By then, it was $10 million in debt. Expenses in the new facility continued to rise, and income did not keep pace.

An affiliation with St. Francis Hospital and Medical Center, announced in December 1989, initially provided for continued independence under the direction of its own board, but a full merger took place in 1995, and Mount Sinai ceased to exist as an independent hospital.

LEON CHAMEIDES, MD, is the emeritus director of pediatric cardiology at Connecticut Children's Medical Center and clinical professor at the University of Connecticut Health Center. He has an interest in history and genealogy and has researched the history of a number of institutions and eras.

THE PEOPLE OF
CENTRAL CONNECTICUT

HONESTY, COURTESY AND SERVICE:
THE G. FOX FAMILY

Cynthia Harbeson

When Gerson Fox immigrated to Hartford from Germany in the early 1840s, he could not have envisioned the impact he would have on the community. For more than three generations, the Fox family ran one of the most successful family-owned department stores in the country; however, their lasting legacy arose from their deep commitment to the Hartford community.

Like many Jewish immigrants, Gerson Fox began his career as a peddler, selling his goods on the streets of Hartford. In 1847, he opened a fancy goods store with his brother, Isaac. He soon became successful enough to support a family, marrying Hannah Bamberger and fathering five children.

Several times over the years, the store—renamed G. Fox & Co. after Isaac moved to New York—moved into larger quarters, but it always remained on Main Street. Gerson never lost sight of the fact that his success resulted from the support of the Hartford community, and as his business grew, so too did his commitment to that community. A founding

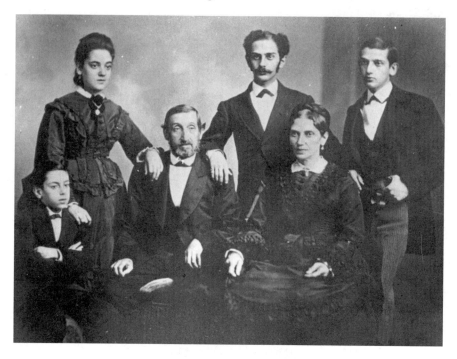

Gerson Fox, founder of G. Fox & Company, with his wife, Hannah, and four of their five children: Isaac, Emma, Leopold and Moses. *Courtesy JHSGH.*

member of Congregation Beth Israel, he served as its treasurer, as well as serving as treasurer of the Hebrew Widows and Orphans Society and contributing to many other organizations.

Gerson's children were all involved in the family business, but it was his second son, Moses, who showed a particular interest, leaving school at thirteen to work full time at the store. When Gerson Fox died in 1880, Moses became president. Under his leadership, the store flourished, despite the need to rebuild—literally—the business from the ground up after a fire destroyed the building in 1917. Like his father, Moses was a philanthropist, generously supporting Hartford's hospitals.

The fire brought Moses's daughter, Beatrice Fox Auerbach, and her husband, George, son of a department store owner in Salt Lake City, Utah, back to Hartford to help her father. George also worked at G. Fox until his unexpected death in 1927 when Beatrice assumed his position as secretary of the board. A decade later, she became

president upon the death of her father, a position she held until shortly before she died in 1968.

Mrs. Auerbach was known for her philanthropy and community involvement, as well as for her business acumen. Although she was especially active in the Hartford Jewish community, her greatest contribution to the Hartford community as a whole was the establishment of the Beatrice Fox Auerbach Foundation. Although the G. Fox & Co. downtown store closed in 1993, the legacy of the Fox family lives on through the philanthropic support of the Hartford community and in the memories of the store's employees and customers.

CYNTHIA HARBESON is the archivist of the Jewish Historical Society of Greater Hartford. She received degrees in library science and history from Simmons College in Boston.

FROM THE CIVIL WAR TO ADOS ISRAEL: THE HOLTZ FAMILY

Leonard Holtz

My great-grandfather Herman Holtz was born in Poland but lived in Leipzig, Germany, until he came alone to the United States in 1857, arriving in New York at age fifteen. On January 24, 1864, he enlisted in the Union army, starting as a private in Company K of the Thirty-ninth New York Volunteer Infantry regiment, known as the Garibaldi Guard and sometimes referred to as Lincoln's foreign legion because of all the immigrant soldiers.

The Thirty-ninth participated in the movements of the Union army toward Manassas, Virginia, and to a lesser extent in the Battle of Bull Run. On May 6, 1864, Herman was wounded in the stomach during the fighting at the Battle of the Wilderness in Manassas. He was honorably discharged on July 1, 1865, and Charles Lincoln, a relative of Abraham Lincoln, signed his pension certificate.

Herman settled in Meriden, where he started a scrap metal business. A religious man, he joined Louis Price and a few others from Hartford

in 1865 to create the early Ados Israel shul. Five years later, Rabbi B. Cohen of Ados Israel married Herman to Price's daughter, Rosa. They chose to raise their family in Hartford because there were very few Jews and no kosher food in Meriden. Herman remained an integral part of Ados Israel until he died on July 9, 1903, in New London. He was hit by a train as he crossed the tracks with a group of Civil War veterans attending a convention.

Herman and Rosa had three children: Willie, Rebecca and Abraham. Abraham became a portrait artist, a photographer and a president of Ados Israel. Three years after his father died, Abraham had such a strong vision of his late father that he painted it onto his workbench boards, where he was sitting. After affixing his father's Civil War button onto the painting, he cut out the boards and framed the painting.

Abraham had three children: Raymond; Herman, named after his grandfather; and Doretta. From his youth, the second Herman loved Ados Israel and became its spiritual leader for more than thirty years. After serving in the army during World War II, he returned to Hartford where he married Norma Flam and raised two children, Leonard (me) and Audrey. Carrying on his grandfather's legacy, he became the

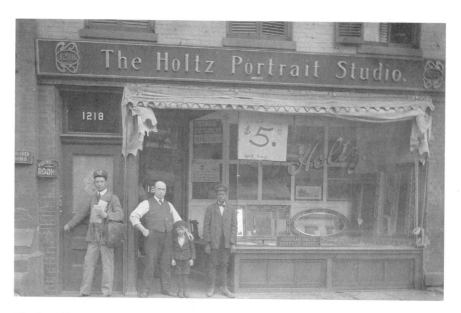

Abraham Holtz and his son Herman in front of his Hartford store. *Courtesy Holtz Family.*

commander of the General Griffin A. Stedman Camp of the Sons of Veterans of Civil War in Hartford.

In addition to the family tradition of raising Jewish children—Melissa, Samantha and Harrison—I have served as president of Congregation Ados Israel since 1990. On September 11, 2001, I responded to a call for Jewish funeral directors to help with the recovery efforts at Ground Zero. A U.S. Army sergeant escorted me to the site where I wore my father's tallis as I blew the shofar that I had blown at Ados Israel since I was thirteen.

ANNIE FISHER:
EDUCATOR, ADMINISTRATOR AND SOCIAL ACTIVIST

Betty N. Hoffman

Annie Fisher was the first Jewish woman in Connecticut to be honored by having a school named after her. Born in Kiev in 1883, she came to Hartford as a child, later attending Wesleyan University as part of an experiment to educate women at an all-male university. She began her career in the Hartford Public Schools as a librarian and English teacher for both immigrant adults and children. At the same time, she continued to study in a variety of institutions, eventually earning an MA from New York University. Always active in both Hartford and Jewish community service—particularly the YWHA, the Emanuel Synagogue Sisterhood, the United Jewish Charities and the Hebrew Home for Children— Annie Fisher became the first female district superintendent of schools under the old school system and later the first female principal of a public school.

When Emma Cohen interviewed Anna Tulin for the Jewish Historical Society in 1983, she recalled having Annie Fisher as her first teacher, a Jewish model for many immigrant children:

> *She understood the foreign child because she had been a foreign child herself. She would instruct you what to read, what to do, to behave yourself. She'd take both of your hands. "Give me your hands, Annie.*

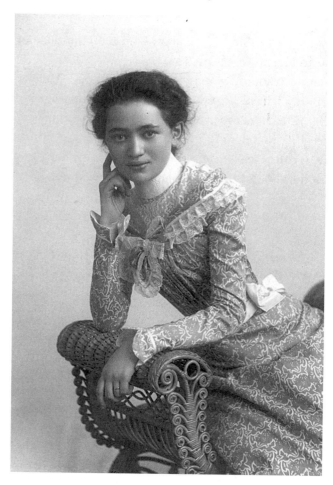

Annie Fisher, the first Jewish woman in Connecticut to have a school named for her. *Courtesy JHSGH.*

Now Annie, say 'thee.' That's good. Now say 'three.' That's good. Now just listen to me. Say 'fifteen.'" We got the accent so quickly you'd think we were American-born. That was her method. It wasn't always the grammar method from the book. She would hold your hands, and how could you go wrong?

According to Annie Fisher's obituary in the *Hartford Courant* on December 26, 1968:

All her life, both personally and professionally as a student, teacher, and executive, had been spent at the Barnard School, originally in the city's

East Side and a melting pot for myriad immigrants to Hartford. Under Miss Fisher's jurisdiction, thousands of children were not only taught and cared for there, but began their Americanization there. Today they and their children in turn can be grateful that Fortune blessed them this way.

CRAFTSMAN EXTRAORDINAIRE: NATHAN MARGOLIS AND HIS FURNITURE

Eileen Pollack

At the turn of the twentieth century, Greater Hartford was the center of the Colonial Revival movement in America. Not only did the region enjoy a long tradition of cabinetmaking and furniture restoration, but it also included a significant number of collectors of American antiques, with Nathan Margolis as the most sought-after craftsman of Colonial Revival furniture.

Margolis was born in 1873 in Janova, Lithuania, a town known for its expert furniture designers and craftsmen. At the age of eighteen, he left for London to work in the prestigious Gillow shop, where he learned English methods of reproducing eighteenth-century designs, including Chippendale and Hepplewhite. At Gillow, he became skilled in making furniture from beautifully grained woods that emphasized form rather than ornament.

In 1893, Margolis joined relatives in Hartford and soon opened a shop on Asylum Street (later moving to Pratt Street and then to High Street) with his father, Charles, and a brother. Although they specialized in repairs and secondhand furniture, Nathan Margolis began to copy the antique pieces brought to the shop for repair.

Virtually indistinguishable from the originals, the copies caught the eye of some of Hartford's most influential citizens, including Everett Lake, who, in 1921, would become Connecticut's governor. Impressed with Nathan's craftsmanship, Lake recommended Nathan's work to his neighbors living on Hartford's fashionable Prospect Avenue.

Word spread and business grew. His timing could not have been better. Margolis reproductions captured the community's desire for

craftsmanship that reflected traditional values and confirmed their own refinement and taste.

Nathan Margolis died suddenly in 1925, leaving behind his wife, Rachel, and five children. Harold, the eldest, took over the business and managed the shop, much like his father had done before him, using immigrant cabinetmakers to reproduce pieces inspired from pattern books and museum collections. Harold continued to sell to the established Yankees and to the newly prosperous Jewish families in the Greater Hartford area.

Morgan "Max" Bulkeley Brainard, president of Aetna Life and Casualty Insurance Company, was a well-known collector and antiquarian. In place of costly and irreplaceable antiques, he chose Margolis reproductions and placed them throughout his corporate headquarters. In a letter to Harold Calick at Colonial Williamsburg, he reflected on Margolis's quality: "Their work has more than a local reputation, and I believe it

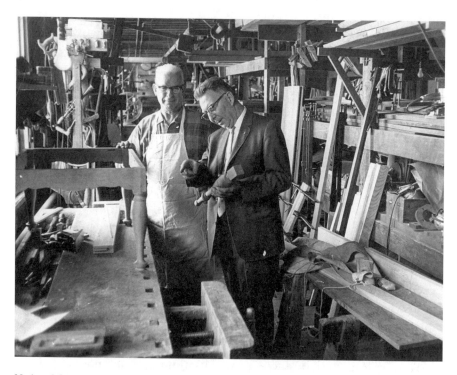

Nathan Margolis's son Harold (right) with cabinetmaker C. Maestre [sic] in the Margolis Workshop, 1946. *Courtesy JHSGH.*

is so generally admitted that no other organization reproduces antique furniture more faithfully or with a higher standard of workmanship than they do."

Wallace Nutting, the most influential proponent of the Colonial Revival, was unrestrained in his praise of Margolis reproductions and, in fact, ordered work from the shop to resell to his own customers. In an appreciative note to Nathan Margolis in 1922, he observed, "It is the best work in America, and you deserve the highest success."

In 1945, Beatrice Fox Auerbach, president of the G. Fox & Co. department store, commissioned many custom-made Margolis pieces to help furnish Connecticut's newly acquired Governor's Residence at 990 Prospect Avenue. Mrs. Auerbach filled the first floor of the Georgian Revival home with Margolis reproductions, including a mahogany Duncan Phyfe double pedestal dining room table, twenty Chippendale dining room chairs, two mahogany Hepplewhite console tables with

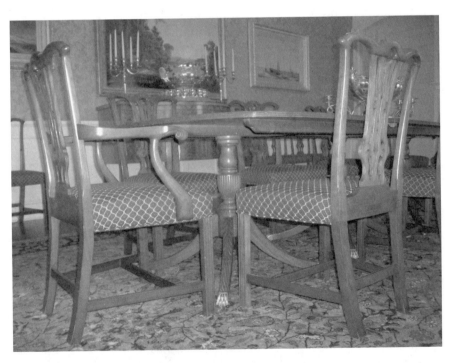

Margolis furniture in the Governor's Residence in Hartford. *Courtesy Governor's Residence Conservancy; Elana Hoffman Larson, photographer.*

satinwood and ebony inlay and two Hepplewhite mirrors with gilt side drops that are still in use today.

Perhaps no one was more dedicated to the Margolis brand than Margaret Thompson Johnston, wife of the judge of Hartford's probate court, whose thirty-nine-page handwritten journal—"Margaret Thompson Johnston's Tambour Desk"—describes each one of her twenty-three pieces of Margolis in precise detail, including their design provenance.

Sally Zwillinger was equally smitten. Wife of a printer of modest means, she had come to Hartford in 1913 from Russia as a girl of thirteen. Her granddaughter, Joan Finger, described her as a proud woman who "would never settle for second best." She was absolutely determined to furnish her home with Margolis. As a result, "she chose to sit on wooden crates in her living room while she waited and saved."

Etta Suisman, wife of Edward Suisman, the owner of a successful scrap metal business and a local philanthropist, was luckier. Mrs. Suisman acquired all of her Margolis furniture in 1927, when she was first married.

After World War II, custom-crafted reproductions fell out of favor due to a shortage of skilled craftsmen and a subsequent decline in workmanship, the easy availability of less expensive factory-produced models and the new fashion for modern styles.

As a result, in the 1950s, Harold Margolis was forced to diversify. He began to sell high-fidelity equipment and cabinets to house the components. Despite his best efforts to respond to changing times, the shop closed its doors in 1974.

During its run, Margolis created commissioned furniture for John D. Rockefeller III, Pierre du Pont III, Hartford's Old Statehouse and Temple Beth Israel in West Hartford. Interestingly, "Margolis fever" sustained itself well into the 1950s in the Jewish community, ten years after almost all of the others had stopped buying.

Perhaps Etta Suisman summed up the phenomenon best when she said, "If you owned it, you knew that you had something special."

Margolis furniture was the subject of Eileen S. Pollack*'s thesis for an MA in the history of the decorative arts degree from the Cooper-Hewitt, National Design*

Museum and Parsons School of Design. She has taught sociology at the University of Hartford and St. Joseph College and served as the executive director of the Connecticut Governor's Residence under Lowell P. Weicker Jr.

KID KAPLAN: THE MERIDEN BUZZ SAW

David Kluczwski

"Kid" hardly describes the professional boxing career of Louis Kaplan—108 wins (26 by knockout) and 17 losses—who started his career when he was only nineteen, thereby earning the nickname of "Kid."

Born in 1901, Kaplan came to the United States from Russia at the age of five with his family and settled in Meriden, where his father bought and sold used goods. Kaplan helped by carrying the wares in sacks on his back because they could not afford a horse or wagon. Bob Morrisette, a reporter for the *Meriden Record Journal*, described Kaplan's childhood: "Kaplan attended the Willow Street School, but his education went no further than the fifth grade. His first job was peddling fruit for Louis Sheftel, climbing stairs to second-and-third-story apartments for a wage of 5¢ a day."

Kaplan's discovery of his ability to fight occurred when a gang of boys framed him for fruit they stole from a vendor's wagon. Kaplan beat the leader of the gang so badly that the policeman, who had arrived at the scene to arrest the actual thief, recommended that Kaplan try his luck at boxing.

Kaplan took up boxing in 1919 at the Lenox Athletic Club in Meriden. At the time, he owned only sneakers, a belt and a pair of green tights. His first fight netted him a total of $8.00, and he recalled that $1.25 of it remained after he gave the rest to his struggling family.

The Lenox Athletic Club was where Kaplan met Moe Levine, the operator of a poolroom and smoke shop who occasionally worked as a sports promoter. Although Levine knew nothing about boxing, he was instrumental in Kaplan's start as a professional because he introduced Kaplan to Dennis McMahon, a boxing promoter. McMahon, who bought Kaplan's contract, proved to be a great help in establishing the young boxer's path toward success.

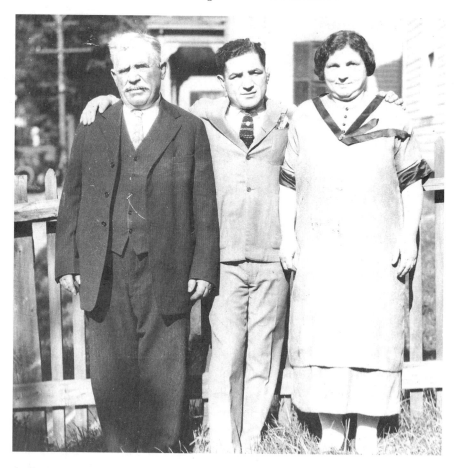

Louis "Kid" Kaplan with his parents, Abraham and Sadie, circa 1930. *Courtesy Rosanne Kaplan Dolinsksy.*

As the ranks of Jewish boxers grew, they became role models in their communities. In *Sports and the American Jew*, Steven Riess notes that the skills they exhibited in the ring countered stereotypes that labeled Jews as weak and cowardly. This stereotype was derived, in part, from the jobs many Jewish immigrants held as either peddlers or tailors.

Despite his raw talent, Kaplan did not typify the ideal boxer. He was short, only five feet, four inches, and his arms were short as well, limiting his ability to reach his opponent. However, whatever Kaplan lacked in physical ability, he made up for in heart, and soon he earned a new nickname: the "Meriden Buzz Saw."

The name originated from Kaplan's fighting style, which included his refusal to stop punching until his opponent wore down. He never turned down an opponent and gave his all in the ring. Kaplan also took his training and preparation for fights to the highest of levels in order to be at his best during a fight. Manny Leibert, a longtime boxing promoter in Connecticut, told the *Jewish Ledger* in 2006 that Kaplan "would run from Hartford to Meriden sometimes just to keep in shape."

All of Kaplan's training and his determination in the ring led to the crowning achievement of his boxing career, the Featherweight Championship of the World in 1925. On January 2, with more than two thousand friends from Meriden in the crowd, Kaplan took on Danny Kramer of Philadelphia at Madison Square Garden in New York City. The *Meriden Daily Journal* reported that it took Kaplan only nine rounds out of fifteen to defeat Kramer and win the title. In the crowd were his proud parents.

At a celebration at their home the day after his victory, his mother, Sadie, told the *Meriden Morning Record*, "I am the happiest woman in the world. I want to thank Meriden for all it has done for my boy. I am

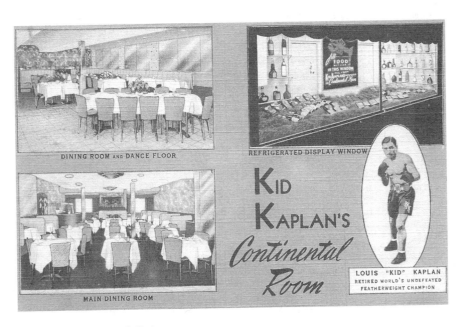

Courtesy Rosanne Kaplan Dolinsksy.

so pleased with the reception, the fine way they treated him Saturday night." Pride was not all he provided his parents. Kaplan earned $11,500 from his championship bout with Danny Kramer, money he used to buy a home for his parents.

Kaplan's fans included many other fellow Jews. As a fighter during his thirteen-year career, Kaplan never hid his Judaism, sporting a Jewish star on his boxing trunks. By wearing the star, Kaplan made Jews, who otherwise did not know much about boxing, aware of the sport. He also wore the star because, as Manny Leibert said, "It gave him a sense of pride and also gave fellow Jews someone to cheer for."

Kaplan's daughter, Rosanne Kaplan Dolinsky, recalled that "the Jewish people were certainly very proud of him, and youngsters all around thought he was great and could relate to him." The *Ring Record Book* voted him one of the ten best featherweights of all time. Kaplan's boxing career was forever honored with his induction into the International and Connecticut Boxing Halls of Fame and the International Jewish Sports Hall of Fame.

David Kluczwski is a graduate student in public history at Central Connecticut University. His longer article on Kid Kaplan appeared in the Hog River Journal *in the fall of 2009.*

Marlow's for Everything:
George Marlow and His Store

Bruce A. Marlow

For nearly a century, downtown Manchester's historic Main Street was blessed with civic pride furnished by Marlow's Department Store, which operated continuously under my family's stewardship for more than ninety-one years. Upon its closing on August 24, 2002, news reports celebrated the life and legend of Marlow's—Connecticut's then-oldest retail firm.

Marlow's was founded by my grandparents, Lena and Nathan Marlow, Russian-Jewish immigrants who settled in Manchester in 1910 and the following year opened a five-and-dime at Brainard Place and Main

Street. In 1924, the store relocated to a handsome Romanesque Revival edifice at 867–869 Main, the site of the once-eminent Orford Hotel.

For decades, the store retained its late '40s period interior: wooden counters, checkerboard linoleum-tile floors, mechanical cash registers, hand-painted counter signs and cute price stickers (often handwritten and always friendly). No computerized checkout-scanner ever diminished Marlow's, where the staff likely knew you by name.

George H. Marlow, son of the founders and my father, was born on Main Street in 1914. A Harvard-educated attorney and member of the Connecticut bar, Dad served bravely in World War II before joining his parents in business and shepherding his single client, Marlow's, for more than fifty years. He doubled the size of the original shop, rezoned and revitalized its uninspired neighborhood, created parking facilities and deployed a dauntless slogan: "Marlow's for Everything."

Marlow's, truly a "small box," was both a tradition and an anachronism. Believing that Marlow's competitive spirit could trump size, Dad stubbornly resisted the wave of bigger-is-better that emerged in the mid-1950s. Marlow's calling was to render affordable solutions,

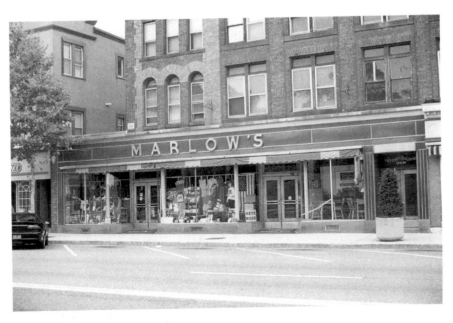

"Marlow's for Everything"—service with a smile. *Courtesy Lillian Marlow.*

honor the promise and grace of personal service—always with a smile—and support the community by giving back.

Notwithstanding a proud Jewish heritage, Marlow's never met a holiday it didn't salute. For many years, its attractions included a live Santa Claus, sure to delight children (electric menorahs were nonetheless nearby), and a menagerie of Halloween outfits sure to spook parents.

Among the more than sixty-five thousand items stocked by Marlow's were Mason jar rings, Venetian blind cleaners, a dizzying array of hairnets, authentic Mickey Mouse watches and four flyswatter choices, as well as furniture, luggage, office gear, clothing, shoes, Girl Scout and parochial school uniforms, hardware, housewares, toys and notions. It hosted services as well: shoe repair, tailoring and reweaving and a beauty salon. In 1963, Marlow's proudly introduced Manchester to the ten-cent photocopy. The copier, albeit balky, remained in service for the next thirty-nine years!

Priding himself on the passion and power of "service with a smile" and "to Main Street thru Marlow's," Dad ensured the longevity and service of every product the store had ever sold (and many it hadn't), from Depression-era Presto pressure cookers, to '40s Victor hand-crank adding machines, to '50s Lionel trains, to '60s Barbie dolls, to '70s Toro snowblowers, to '80s Speak & Spell learning aids, to '90s Samsonite two-suiters. He continued to preside over Marlow's daily routine until well into his eighties.

As Marlow's was very much a family affair, its story would be incomplete without a family anecdote.

In late 1955, Dad asked me what I wanted for my ninth birthday. What I wanted was a Pakette-brand crystal radio set with a built-in earphone. Early one Saturday, Dad and I headed to Hartford to visit Hatry's, a well-known electronics house that was supposed to stock everybody's favorite circuits.

We arrived just as the store opened and were promptly told that what we sought hadn't been made since 1949 and that nothing close to what I wanted was currently available. I knew the salesman was wrong, but, well, I was barely nine. What followed was a succession of disappointing visits to other shops—from East Hartford to Hamden. We arrived back in Manchester exhausted, discouraged and empty-handed.

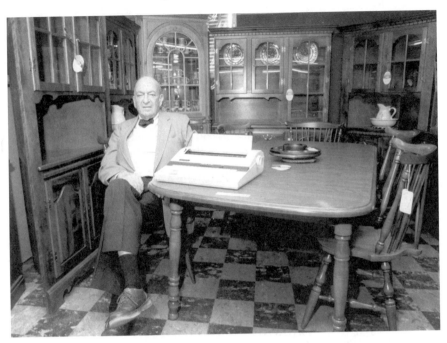

George Marlow in the furniture department of Marlow's. *Courtesy Lillian Marlow.*

At this point, Dad said to me, with instinctive optimism, "Why don't you have a look in the subbasement of Marlow's and see if there's something else of interest." To humor an eager parent, I mechanically said, "Sure," but with no expectation of unearthing anything useful. I'd pawed around down there many times. What was there was Christmas tinsel, tons and tons of it, made of real metal. This stuff was sharp edged and way too heavy for its cellophane wrapper—the packages always broke.

Still, the odds of finding anything appealing to commemorate my birthday—let alone something snappy and electronic—were slim to none. I dutifully walked down every aisle, tripping over picnic table covers, seat cushions, bales and bales of brooms, loose snow shovels, odd glassware, playpens in various states of disassembly, replacement wagon wheels—the ones for covered wagons—and even a stash of too-flimsy promotional tin rulers from American Express Travelers Cheques emblazoned with Marlow's logotype. Nada. Zilch. Zip.

I still had a shred of hope. On a top shelf were a few hobby sets. Wow, unbelievable! It was not the affordable Pakette-brand crystal radio,

but something much, much better that I hadn't even imagined might materialize: a Remco Radio Science Crystal Radio Kit "Complete with External Headphone! Hear Real Radio Programs, Sensitive Fixed Crystal, Modern Plastic Cabinet, Easy to Assemble!" Marlow's actually had two. Happy Birthday to me!

When I trudged back up the four flights of stairs to the office and displayed my prize, Dad was beaming. As a true-blooded merchant, he wrote up the adventure and sent it over to the *Manchester Herald*, illustrating once again that Marlow's really does have everything. A family excursion had scored the radio set and great publicity for the store.

BRUCE MARLOW, the son of George and Wilma Marlow, is an entrepreneur and business advisor. His sister, Joan Marlow Golan, is a publishing executive.

ABRAHAM RIBICOFF: CONNECTICUT'S ONLY JEWISH GOVERNOR

An Autobiographical Sketch

My parents, Sam and Rose Sablotsky Ribicoff of Slomin, Poland, were part of the massive wave of Jewish Polish-Russian immigrants who came to the United States in the first decade of the 1900s. They settled in New Britain, Connecticut, a factory town of some forty thousand people.

I was born on April 9, 1910, on the third floor of a tenement house on Star Street. We always lived on the third floor because the rents were a few dollars cheaper. There was seldom an extra dollar around. My father's first job was operating a wood-turning lathe in a factory. Then he had a bread route, getting up at 3:00 a.m. and picking up the bread at the bakery very early in the morning so his customers could have hot rolls and bread for breakfast.

My mother was a great lady. She was the leader in the Ladies Aid Society to help other immigrants. I recall her as constantly busy, raising money for food and clothing for people who had more than we did. No one would know that because she had great pride.

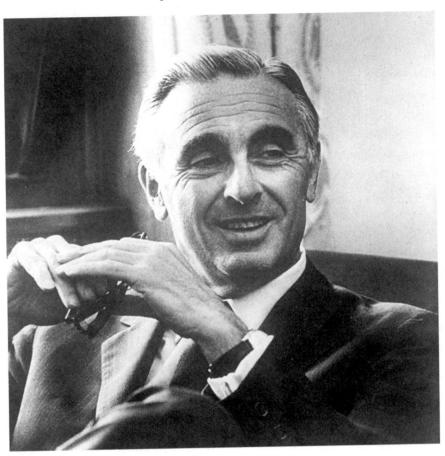

Governor Abraham A. Ribicoff. *Courtesy JHSGH.*

Rose and Sam Ribicoff were devout Orthodox Jews. With nostalgia, I recall the strict observance of all Jewish holidays, accompanying my parents to the synagogue, the religious ceremonies and the special holiday dishes prepared by my mother—an outstanding cook. After school hours, I attended Talmud Torah and was duly bar mitzvahed.

It was my special fortune to have been born and raised in New Britain, the "Hardware City" of the world. Its factories were basically owned by the Yankee descendants who founded Connecticut, and its workers were the immigrants who came from every Western European country. There were no ghettos in New Britain. Varied people of all nationalities and religions lived side by side.

New Britain gave me a great boyhood. At ten, I peddled copies of the *New Britain Herald*. I worked at Mr. Tractenberg's milk dairy, worked in Gitlen's Garage on Elm Street pumping gas, caddied at the Shuttle Meadow and Indian Hill Golf Clubs and worked after school in Adler's Dry Goods Stores on Main Street. At sixteen, in the summer, I had a pick-and-shovel job digging ditches on a new road being laid on Stanley Street. With all these jobs, my parents, unlike many others, never took a dime of my earnings; they insisted that they be deposited in the savings bank to go toward a college education.

Graduating from New Britain High School in February 1927, I got a job as an expediter at the G.E. Prentice Manufacturing Company in Kensington. My home was about four miles away, and I rode my bicycle to and from work. My job was to go between the office and the factory floors. One person who became my close friend was Ed Conlin, an Irish Catholic, who was foreman of the tool room. We went through the election of 1928 together when anti-Catholicism was rampant against the Democratic candidate Al Smith. We used to cry together. At that time, I was determined to go into politics and help eliminate prejudice of all kinds.

Having married Ruth Siegel in 1932, we returned to Hartford [from Chicago, where he graduated from the University of Chicago Law School in 1933]. I took the bar [examination] and became associated with Judge Abraham Bordon. Like all businesses, the legal profession was in the doldrums. I had a chair in the library and was paid whenever I did some work for the judge. Judge Bordon was a wonderful man of great character, with high ethical and professional standards. He was my mentor, and after a few years, he made me his partner in the firm of Bordon & Ribicoff.

I jumped into politics immediately, starting as a ward heeler in Hartford's Twelfth Ward. On the same floor—750 Main Street—there was another young lawyer, John Bailey. We became close friends. Over corned beef sandwiches from the old Empire Restaurant across from city hall, we talked about what we would do if we controlled the Democratic Party. The Hartford party boss at that time was T.J. Spellacy, a brilliant lawyer and politician.

In 1938, the Democratic Party was split. In the Democratic Convention to nominate Hartford's representative to the Connecticut General

Assembly, John Bailey nominated me against the organization nominee, and we won. I can still see T.J. Spellacy—all six feet, four inches standing up, lifting his hands toward John Bailey and saying, "John, I give you the party." John took it and went from town chairman to state chairman to national chairman. So I went to the Connecticut legislature and loved it.

ABRAHAM RIBICOFF went on to become congressman from the First District, governor of Connecticut and secretary of health, education and welfare during President John F. Kennedy's administration. Ribicoff, who served Connecticut in Congress for twenty-two years, died in 1998. Excerpted from Connecticut Jewish History, The Journal of the Jewish Historical Society of Greater Hartford *1, no. 1 (1990).*

MIDDLETOWN'S HIDDEN TREASURE: THE SHAPIRO FAMILY MUSEUM

Stephen P. Shapiro

Middletown's Adath Israel Museum is a story of respect, long-term love and dedication to Judaism, Zionism, synagogue, family, history and art. When Joseph A. Shapiro first came to the United States in 1887 and finally settled in Middletown, he had few skills and almost no money. He became a peddler, taking the boats that traveled from Middletown to New York to buy the goods he carried from door to door, selling to immigrants from Poland, Russia, Italy and Ireland, learning how to converse with them as he went.

In 1899, his oldest son, Harry, and other family members joined him in a partnership that was to become J.A. Shapiro and Sons Department Store on Main Street in Middletown. The store was a Middlesex County tradition and landmark until Harry's son Nathan and his grandsons, Stephen and James, closed the store and retired in 1987.

From almost the moment Harry arrived in Middletown, he became active in the community and dedicated as one of the founders of Adath Israel Synagogue. His marriage to Rose Schwartz(buch) was the first to take place in the synagogue, then located on Union Street. Their *ketubah* (marriage certificate) is currently displayed in the museum.

Rose and Harry made sure that they instilled in their children and grandchildren the ideal that they must do absolutely their best to give of themselves to family, religion, community and charity. Their son, Nathan, followed his parents in growing the business, contributing to charities and serving both the Jewish and wider community around it.

While Nathan volunteered to serve in Europe during the five years of World War II, his eyes opened to the tragedy of the Holocaust. He helped liberate several concentration camps. During this period, he began to learn about antiques of all kinds, especially German porcelain and Judaica. Being a family man with a young son, Stephen (me), at home and not being a smoker, drinker or gambler, he saved his combat pay. With this extra money, he was able to buy antiques and send them home.

In the 1950s, he and my mother, Shirley Feinberg Shapiro of Hartford, began traveling everywhere, including to places that were not quite ready for tourists. They were seeking historical knowledge and beauty, always in search of antiques and Judaica, at first for their personal collections

A rare nineteenth-century Eastern European Purim gragger with a Cossack representing Haman. *Courtesy Rose and Harry L. Shapiro Adath Israel Museum; Elana Hoffman Larson, photographer.*

and then for the museum. This was before anyone else, including most museums and synagogues, began collecting these now rarities.

In 1961, when my grandparents, Rose and Harry Shapiro, celebrated their fiftieth wedding anniversary, their six children and friends thought that there would be no more appropriate and meaningful gift than establishing the Rose and Harry L. Shapiro Adath Israel Museum, now on Church and Broad Streets.

For the next forty-plus years, as people celebrated bar mitzvahs or remembered loved ones, they contributed toward the purchase of "very different" objects of Judaica for the museum. This system worked quite well when our parents' friends were alive and active, but over time, larger museums and synagogues began to compete with us, making it increasingly difficult for us to buy new items. In addition, many of Dad's friends in the antiques business passed on or went out of business. Whenever my father acquired something new, I was the first call he made. I would run over to his house, and we would sit together like two young boys admiring his purchase and talking about the stories that came with each piece.

I have always thought that when people of different faiths and backgrounds get to know one another, it helps to foster understanding and knowledge of their religious beliefs and customs. Our museum does this well. But we have reached a time when we must take measures to preserve—to clean, catalogue and safely display—our collection for future generations.

With the active help of the new board of directors, especially our president, Seth Axelrod, and past-president Eliot Meadow and the support of our new rabbi, Seth Haaz, I am now discussing with the new director and professor of Judaic Studies at Wesleyan University, Magda Teter, PhD, how we can grow and improve.

Dr. Teter would like to use our museum as a very important part of her Jewish Studies curriculum. We are considering permanently loaning some of the priceless books in our collection to Wesleyan's climate-controlled library vault, where they will be preserved for scholarly use and for our own events.

In the fall of 2010, a Hebrew University professor of Judaic Studies who is especially knowledgeable in Jewish and Hebrew artifacts will use our items as part of his presentations for Wesyleyan students, Adath

The need for preservation: an early eighteenth-century Moroccan Torah and Torah case. *Courtesy Rose and Harry L. Shapiro Adath Israel Museum; Elana Hoffman Larson, photographer.*

Israel members and interested individuals from the community at large. Dr. Teter hopes to have students do individual research projects on our various collectibles, projects they will then share with us. As all of this is in progress, we are writing grants for money to preserve, restore and safely display our Judaica.

Among my favorite items in our collection is a history of the Jews by Josephus. It is in perfect condition, printed in the old German script of the Lutheran period in Strasbourg, dating from 1553. Another is a simple brass Chanukah menorah from seventeenth-century Holland.

The Rose and Harry L. Shapiro Adath Israel Museum is open to visitors by appointment. Please call the synagogue office at 860-346-4709 or Stephen Shapiro at 869-347-6494 to arrange individual or group tours.

"WE FELL IN LOVE WITH THIS COUNTRY"

Nadia Rivkin, as told to Betty N. Hoffman

When you are over forty-six, it is most difficult to start over, to create everything: a place of residence, your job, your social networks, everything. We came here in January 1992. It was Martin Luther King holiday, so the very next day we came to Jewish Family Services (JFS) with our relatives, and we had an interview with Vida Baron, who was head of resettlement, and she introduced us to America.

Nadia Rivkin's Soviet passport with an inside stamp identifying her as a refugee. *Courtesy Nadia Rivkin.*

Our relatives rented an apartment for us, and JFS helped to pay our security deposit and first month's rent and also gave us a check for food. Because we were refugees, we were allowed four months to have this financial support and medical insurance for the whole family, and food stamps.

We came to Beth Israel synagogue and had a placement test for English class. The next day, we started class and to look for jobs. We put together our resumes, and every week we had a meeting with the counselor at the JFS.

My older son and daughter-in-law did not attend ESL classes because their English was perfect. My son got a job in one and half months as a computer programmer. Dimitry now works in information technology.

My youngest son came to King Philip School. Then he went to Hall High. When we moved to Simsbury, he graduated from Simsbury High, then Dartmouth, summa cum laude, and now he is in Harvard Law [School].

My mother was seventy-six when she arrived, and after two strokes, but she somehow mastered English enough for everyday conversations in stores and enough to take the citizenship tests. I was proud of her.

I did not dream about [finding a job as a civil engineer] because it was a very bad situation in the job market, and I really did not want to go on public assistance. So I found a job in Hartford Steam Boiler cafeteria as a baker's assistant. It was a good job because I had medical insurance for whole family.

My husband, Boris, delivered newspapers. Then he delivered pizza, but he was looking for a professional job. He got a job at Birken Manufacturing Company. In one year, he was laid off. We were realists when he lost his job. We did whatever we could. We worked as waitresses at Jewish weddings. I distributed coupons in supermarkets.

I did not have time to read newspapers, but one day Boris saw an ad that the Jewish Federation was looking for someone with a college degree who was willing to get an education as a social worker because they needed a Russian-speaking social worker. Boris said, "This is just for you. You always do it as a volunteer, and now you can do it as a professional." He convinced me to apply.

I still worked at the cafeteria, and for about one year I went at night and took all the basic courses for the program. I was admitted in the

MSW [master of social work] program at the UConn School of Social Work. The Jewish Federation applied for a federal grant to pay for my education, so it was the agreement that after I graduated, I had to work for at least two years for the Jewish Federation, where I still work.

Boris got a job as a lead analyst at the Town of Farmington Waste Water Treatment Facility, his area of expertise, but not his level. He likes his job, and he's happy. We fell in love with this country from first sight, and it made it easier for us because we liked everything here.

From the Revolutionary War to Jewish Renewal: Western Connecticut

Jewish Fairfield County: The Early Years

Linda Baulsir, with Irwin and Vivian Miller

The Jewish presence in Fairfield County can be traced to the colonial era. On June 23, 1698, Moses Levy, the first Jew of record in Stamford, purchased a slave named Dinah from Mary Turney, mother of Samuel Hoyt, the builder of Stamford's oldest existing structure, the Hoyt Barnum House.

Most of the earliest Jews to come to Connecticut were Sephardim. Being isolated from established centers of Jewish settlements, they tended to assimilate into the culture of their largely Congregationalist communities and married outside the faith. Also following this pattern was one of the first non-Sephardic Jews, Andris Trube, who arrived in Fairfield in 1718.

The tax records of 1728 identify Jacob Hart as an early Jewish settler in Stamford. In January 1732, Hart purchased a "mansion house" in the area now known as Columbus Park. By 1738, he was the fifth-largest taxpayer in the town. Hart married Esther Levy, and their three children were the first Jewish babies born in town. He also had a Darien connection, leasing two mills and a house from John Clock in 1737 and purchasing property on the Post Road in 1761.

In 1776, Manuel Myers and his wife, Miriam Pinto Myers, fled British-occupied New York for Stamford. With them came other relatives, including Isaac Pinto, editor of the first English-language Jewish prayer books and High Holiday *mahzor*. When Miriam died in 1781, her husband had to get permission from Connecticut governor Jonathan Trumbull to cross into British-occupied New York so that she could be buried in the Jewish cemetery at Chatham Square. Abraham Davenport, a non-Jewish member of the Connecticut Governor's Council, interceded with the governor, attesting to Myers's patriotism and attachment to the American cause.

The most prominent Jews to take refuge in Connecticut were the families of Isaac Seixas, a Newport merchant, and his son, Gershom Mendes Seixas, the religious leader of the Spanish and Portuguese synagogue, Congregation Shearith Israel in New York. Although Geshom Mendes Seixas brought the Torah scroll and religious books from the synagogue and conducted services in Stratford, the refugees did not form a permanent congregation.

Other New York Jews who were Patriots during the American Revolution fled to Norwalk and Wilton. Among them was Myer Myers, a silversmith who at the time was as well known as Paul Revere. After the burning of Norwalk in 1779, the Myers family settled in Stratford before returning to New York. Most of the refugees, including the Seixas family, returned to their homes after the war.

In 1804, Moses and Esther Lopez Gomez arrived in Stamford with their family. When Esther's sister, Maria, married Jacob Levy Jr. of Wilmington, North Carolina, the following year, Moses officiated at this first recorded Jewish wedding in Stamford with a minyan.

Joseph B. Nones advertised in the *Stamford Advocate* in 1847 that he had a commission from the governor of Connecticut to function as an attorney. A descendant of Private Benjamin Nones, who came to America from Bordeaux, France, to fight with Lafayette in the American Revolution, Nones himself served as a midshipman in the War of 1812.

The pioneer Jewish settler in Greenwich was Abraham Hayes (1728). Several years later, two of his brothers, Jacob and David Hays, purchased the original structure now known as the Bush-Holley House. Greenwich, however, never developed—as did Stamford, Norwalk and Stratford—

The wedding of Sayde Cohen of Greenwich and Morris Steinberg, February 14, 1925. *Courtesy JHS/LFC and the Historical Society of the Town of Greenwich.*

into a seaport town, discouraging young Jewish entrepreneurs. It was not until the 1880s that the next Jewish family settled there.

Starting in the mid-1850s, a trickle of German Jews began to arrive in Fairfield County. Even before they built their synagogues, the new congregations would clear land for burial use. Bridgeport, Greenwich, Stamford, Darien, Norwalk, Fairfield and Danbury all have early Jewish burial grounds.

In 1856, Wolff Cohen, a new arrival in Stamford, advertised ready-to-wear clothing and had "five hands" working for him. Two Cohen sons, Samuel and Byron, were the first resident Jewish attorneys, with Samuel Cohen becoming a judge of the probate court in 1876. Although the Cohens were in the vanguard of Jewish settlement in Stamford, by 1884 the family had moved to New York.

In 1867, Robert Weekes Nathan, the descendant of an old New York Jewish family of colonial distinction, rented a home for his family

on Strawberry Hill in Stamford overlooking Long Island Sound, thus starting a trend. By the 1880s, Fairfield County had become a place for the wealthy Jews from New York to establish summer residences.

The earliest Jewish settler in New Canaan was Louis Drucker, a tailor who arrived from Hartford in 1869. Drucker became a town constable and a member of the volunteer fire department.

Darien also had several Jewish families in the 1890s and a Jewish Civil War veteran at the Old Soldier's Home. However, few Jews remained in Darien, as the town was developing very slowly, and by World War I real estate restrictions were becoming the norm. Not uncommon throughout

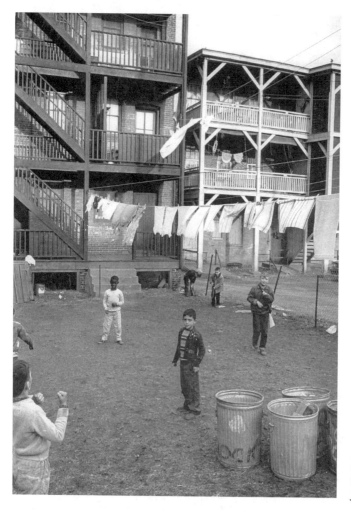

A Pacific Street tenement in Stamford. *Courtesy JHS/LFC.*

the nation during this period, residential restrictions, which prohibited Jews from living in some areas, were a factor limiting Jewish settlement in other parts of lower Fairfield County as well.

Starting in the late 1880s, Stamford, Norwalk, Bridgeport and, to a lesser degree, Danbury became magnets for a new wave of immigrant Jews from Eastern Europe. Stamford's first Jewish congregation, Agudath Sholom, chartered in 1889, did not survive, although a successor by that name was established there in 1904. In 1899, a Hebrew Society was founded in South Norwalk, and in 1906 its congregation, Beth Israel, built a distinctive wood synagogue. It is the oldest existing house of worship—although no longer Jewish—built by a Jewish congregation in Fairfield County. By 1896, there was a large enough group of Jews to establish Congregation B'nai Israel in Danbury.

Over time, Jewish entrepreneurs migrated to the smaller towns of Fairfield County, establishing retail, manufacturing and service businesses in places like the Georgetown section of Redding, Wilton, Newtown, Monroe and Easton. In addition, Baron de Hirsch funded a

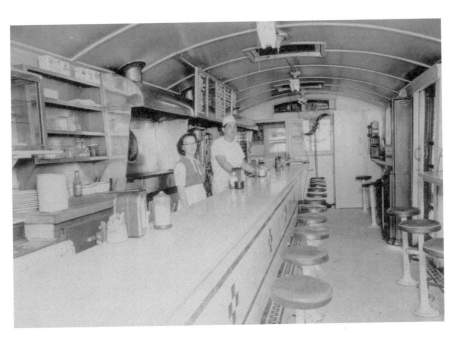

Doris and Joe Blum's diner, Main Street, Norwalk, circa 1950. *Courtesy JHS/LFC.*

farming community, called "Little Palestine," along Huntingtown Road in Newtown.

With restrictive barriers currently a thing of the past, the once small Jewish community of Greenwich, for example, has grown to about 10 percent of the town's population, and Jews have made a significant contribution to the economic, political and social development of Fairfield County.

LINDA BAULSIR is an archivist of the Jewish Historical Society of Lower Fairfield County (www.stamfordhistory.org/jhslfc.htm). IRWIN MILLER, the historian of JHS/LFC, was one of the eight original incorporators of the society. They are the authors of The Jewish Communities of Greater Stamford. *VIVIAN MILLER is the archivist emeritus of the JHS/LFC.*

YES, THERE ARE JEWS IN TORRINGTON

Joyce Peck

Forty-five minutes from Hartford, thirty minutes from Waterbury and an hour from New Haven, Beth El Synagogue is the only synagogue in Torrington and the only one in Litchfield County affiliated with the United Synagogue of Conservative Judaism. Members come from throughout Litchfield County and part of Hartford County.

Although the synagogue's history dates back at least to 1906, no one knows when the first Jews arrived. The development of the Torrington Jewish community mirrors the immigrant experience elsewhere. Jews, like others, were drawn to the area by family or friends and the prospect of jobs and business opportunities. Naomi Pincus Cramer recalls:

> *My grandparents, Joe and Esther Pincus, came to Torrington around the turn of the twentieth century. Their three children were born here: Edythe in 1902, Jack in 1906 and Ben in 1910. Joe Pincus became a peddler of dry goods in the Torrington area. During World War I, Joe and Esther opened the Joe Pincus Dry Goods Store on Water Street. For most of this period, Joe continued peddling with a horse and wagon.*

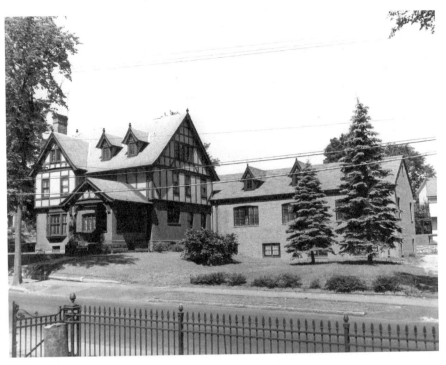

Beth El Synagogue, Torrington, circa 1950s. *Courtesy Beth El.*

Gerald Libby's favorite story about moving to Torrington is about his father, David Libby:

> *At the age of seventeen, with hard times in Europe after World War I, he and a friend left their families and homes in Russia and sailed to Argentina because they could not get visas to enter the U.S. After two years in Argentina, he was able to enter the United States. Arriving at Ellis Island, his relative in this country arranged for him to have a job in a mattress factory in Hartford. After about five years in Hartford, he and another Jewish man, Jacob Apter, started a small bedding shop in Bristol. After a year, they weren't making enough to support two families, so they opened a branch in Torrington. The Torrington store did so well, they closed the Bristol store.*

Local lore has it that the first effort to formally organize the Jewish community came in the early 1900s and that the Sons of Jacob Cemetery,

still in use today, came before Congregation Sons of Jacob, the first synagogue. Beth El Synagogue records tell what happened:

> *The body of a Jewish farmer was deposited on the door steps of a Mr. Moss on Main Street where Moss had a cobbler's shop. Mr. Moss contacted some of the early Jewish settlers and $50 was raised to purchase a cemetery plot. The name of the dead man was unknown...A gift of land was made to the Jewish community by Mr. Travis. Later Mr. Travis contributed $1,000 toward building the little chapel on the cemetery grounds. A Chevrah Kadisha [burial society] was formed and money raised to place a fence around the cemetery grounds.*

The first building, purchased in 1910 for use as a synagogue, was at 296 East Main Street. The Reverend Mr. Lemon was the first spiritual leader. The Reverend Harry Radunsky came to Torrington in 1916, when the Sons of Jacob Congregation was formed. Additionally, the women of the community organized a Ladies Aid Society.

Jeannette Radom recalls her family's connection to Torrington and to the synagogue:

> *Leo and Clara Libby Radom came to Torrington about 1913. They came directly from Rockville, where they were married and where Clara's family lived...Between 1919 and 1921, Leo Radom and Louis Temkin became business partners as Radom & Temkin, dealing in cows and horses throughout Connecticut. Even today, people can still remember the arrival of carloads of livestock at the train station and the parade of the animals down Water Street to the barns on what is now Willow Street.*
>
> *Leo Radom was a charter member of the first organized synagogue in Torrington and remained involved with the synagogue affairs until his death in 1965...He and Mr. Temkin held the mortgage on the original Litchfield Street building, the site of the present synagogue.*

The congregation outgrew its quarters and voted to purchase the Swedish Church on Spear Street, dedicating the building in 1919. The congregation's full-time Hebrew School was organized in 1922 to include

Religious school, Beth El Synagogue, Torrington, 1951. *Courtesy Beth El.*

all age groups. The first Sons of Jacob wedding took place in 1920, when Pauline Diamond wed Jack Lebed.

In 1929, Sons of Jacob purchased the Braman property on Migeon Avenue. At that time, differences arose, and the seventy-member congregation split into two groups. Congregation Sons of Jacob moved to Migeon Avenue, and the Beth El congregation remained on Spear Street. Rabbi Radunsky officiated at both synagogues.

Beth El grew so much that it purchased the Brooks house and land, the site of the present synagogue, on Litchfield Street, dedicating the new synagogue in 1942. Congregation Sons of Jacob dissolved completely in 1945 and disposed of its real estate.

A new group, the Torrington Brotherhood, was formed and, in conjunction with the sisterhood, planned a Conservative group that became Emmanuel Synagogue in August 1946, with services held in rented quarters on Main Street. By 1947, Beth El Synagogue

and Emmanuel Synagogue had united under the name of Beth El Synagogue.

Plans for a sanctuary addition to the Brooks house were unveiled in 1949. The Brooks house itself was torn down, and an office/classroom structure, connected to the sanctuary, was built in its place in 1959. That building is still in use. The congregation offers a rabbi, holiday observances and life-cycle coverage, a religious school, youth programs, adult education, the Litchfield County Chapter of Hadassah and an affiliation with Sons of Jacob Cemetery.

Joyce Peck is president of Beth El Synagogue in Torrington and a retired journalist. She has lived in the Northwest Corner of Connecticut for forty-five years.

Healer and Humanitarian

Jacob Nemoitin, MD, as told to Ronald Marcus

When my father arranged for me to interview Dr. Neomitin, we did not dream that he would die three days later. In 1887, Dr. Nemoitin and his father fled the repression in Russia and immigrated to the United States. Later in life, he returned to the photography he had learned as a teenager and began to write poetry and paint.

When I was nineteen, I entered the Columbia University Medical School, the College of Physicians and Surgeons. The fee in the medical school was only $100 a year and books, which I easily could save up [working for a photographer], especially during my vacations. The study at the medical school was very difficult.

After I got my diploma, I began to look for an internship. At that time, internships were very hard to get, particularly for a Jewish boy. The only opportunity was in a Jewish hospital, which were at that time very few. Beth Israel was a very democratic hospital, and they just took them according to their merits, so I got an appointment in the Beth Israel Hospital for two years [where he met and later married nursing student Frances Einhorn].

Word came to me from Stamford that Dr. Loeb, who was the first Jewish doctor practicing in Stamford, died from typhoid fever, and his

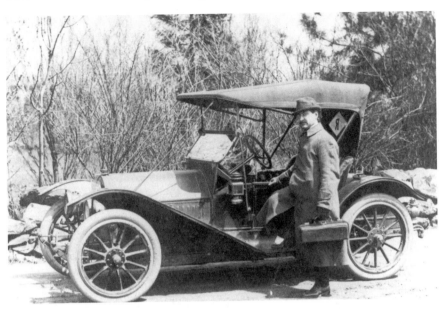

Dr. Jacob Nemoitin preparing to make house calls in his Underslung Regal. *Courtesy JHS/LFC.*

place was open for occupancy. I had most of the Jewish patients, and I also became acquainted with many foreign patients, as I could speak Russian and Polish. I started also to study Italian, mostly from Italian medical books. There was a pharmacist by the name of Mr. Champagne on Main Street. He explained to me that he takes care of a good many of foreign patients and that he would be very glad if I would send the prescriptions to him and he'll try recommending patients.

My practice began to increase quite a lot, and I had considerable trouble with the small hospital we had here. There was a superintendent at that time, a certain Miss Wilson who was in charge of the hospital, and for some reason, she, I believe, did not have much sympathy for Jewish people. At least, I thought that was the case with me, and every opportunity that she had, she made it very hard for me.

It was also during the time when Mr. Champagne recommended me a little boy, a Polish boy, that was very ill. When I came with my bicycle to see that boy, he was having pneumonia. Now the pneumonia wasn't of such a very bad caliber, but instead of getting a crisis, he developed pus in his chest.

So I called Dr. Dichter to help me, and we opened up his chest to put in a tube, and the pus came out, and the child began to improve, but the improvement was very slow. And the woman was very poor. She had six more children, and her husband was a carpenter, and all he used to make was six dollars a week. My fee to her was very small, but still she felt that she couldn't pay much. When she saw that the child was very, very sick, she said, "Doctor, I know you are trying so much, but we haven't got much money, and if God wants him to die, let him die." So I said, "Oh, no." First of all, I became very fond of that child because he was so handsome, and he had beautiful blue eyes and blond hair, and he was so appreciative when I do something for him. So I told her that whenever she'll have money, she will pay me or even doesn't have to pay, but I'll keep on. "Well," she says, "If you are willing to take care of him, I wouldn't stop you."

As he got well, he used to run around the street, and when I used to pass by with my horse and buggy, he used to shout, "Oh, here is my doctor!" He used to always want that I should give him a ride. So I used to give him a little ride, and then I used to give him a nickel, and he would buy some goodies and feel very happy.

Then, meantime, my son became of age, and he got to be in the medical college. So one time he tells me, "You know, I have a boy in my class, and he says that he has a mark on his chest from an operation that you performed on him."

One time, as I was looking over my medical journals, I see an article in the *New England Medical Journal*. Dr. Rudimanski, I recognized right away who it was. Tears appeared in my eyes thinking how many babies I have saved by saving him, for he is such a wonderful pediatrician.

Finally is ending my story. I'm eighty-two and a half years old, and yet, I'm practicing. The reason I do it is because if my mind is clear, I can do so much good. If I would like to live over again, I would want to practice medicine.

This article is adapted, with permission, from Dr. Nemoitin's oral history on file at the Stamford Historical Society. RONALD MARCUS, a retired scientific glass blower, has volunteered at the Stamford Historical Society for more than fifty years. He is currently the librarian.

Murky Winter (1945), painting by Dr. Jacob Nemoitin. *Courtesy Stamford Historical Society.*

WHAT WE DID FOR FUN:
A CONVERSATION ABOUT BRIDGEPORT

As told to Betty N. Hoffman and Diane K. Cohen

GERTRUDE KANTROWITZ: My father bought our house, I think, in 1924: North Avenue, the corner of Laurel. I went to Maplewood Elementary School. That was Northwest Bridgeport. There was no distinction between the Jewish and non-Jewish children in the neighborhood. I never had any problems. I had to take piano lessons and dancing lessons. My father told my mother, "Don't let her take toe dancing." He was afraid I would be a ballerina. He had nothing to worry about, but I must have enjoyed it.

DOROTHY HASSMAN: The '30s: I remember being a little girl in a short dress. In the summer we used to have a great time. Because there were

The Boulevard, Seaside Park.

not that many cars, we'd skate in the streets. We'd play hopscotch in the streets. I used to do a lot of reading. I used to walk to the library. In the summertime, we'd go to the beach. There was a big, big tree on the grass at Seaside Park, and all of the Jewish families would congregate under there. They brought enough food for days.

SELMA ROSENBLATT: Seaside Park, that's a great place. There were hot dogs stands down at the foot of Main Street. We used to take the kids and spend a day at the park. There was a man called Peter that used to go around and pick up all the debris. If there was something on the grass, he would say, "You dropped something. Pick it up."

We used to go on a Sunday with my husband. Sometimes the women would play cards, just sit and chat. Down at the far end, the southern end of the beach, there was a lighthouse. At low tide, you could go out to the lighthouse, so we would take the kids down there. It was just a lovely day, a family nice day, the intermingling of all kinds of people. Then along came a storm one day, and the wonderful tree that we all sat under was uprooted, and that was the end of that.

CAROL ENGELMAN: I remember Seaside Park because my grandmother lived right across the water. You could see the beach and the park on the other side. I loved to swim. I loved the water, and it was

The Poli Theater on Main Street in Bridgeport.

nice and clean in the 1940s, and you were safe there. I used to like Pleasure Beach.

RITA WILCHINSKY: Pleasure Beach was a beach and a playground where you could go on a roller coaster and a merry-go-round. The kids loved it. They had a dance hall there near the water. It was cool, and everybody was really nice.

SELMA: I was married at that time and brought my children there. The man who ran the roller coaster took a liking to my children. He didn't know that my oldest son's stomach was always queasy, so he made the ride go longer. As a result, I had a sick son at the end of the ride, but the kids loved it.

CAROL: I had a couple of girlfriends, and we used to go to down to the movies in downtown Bridgeport.

LAURA BROWN: There were three big theaters. The seats and everything were so fancy. It was like you were going to somewhere elegant— Loew's, the Poli Majestic. We saw all the latest movies. I liked *Tarzan* even though I was too old to like *Tarzan*.

SELMA: The theaters were really beautiful. There were wonderful paintings. We used to go as couples. It was twenty-eight cents to sit up in the balcony. Sometimes we would treat ourselves and go to the Ocean Sea

Grill, which was a restaurant directly across the street, and have dinner there. They had the best food. If we didn't do that, after the movies, there was a kosher delicatessen on the corner of Main and Congress, and we would go in there and buy food and go to somebody's house and eat it.

DOROTHY: Department stores. I loved them. Read's was the classiest. Thursday was a big shopping night because the stores were open until nine o'clock, and everybody got dressed up to the nines and went downtown to have dinner. We ate quite a bit at the Arcade and the Italian restaurant upstairs, and then we would go shopping and spend our hard-earned money. This was girlfriend time.

RITA: If you needed a shower gift, you would go to one of the big department stores. They would wrap the gifts up for free.

SELMA: [During the war] stockings were very hard to get. I remember being in the city with my mother and my cousin. My cousin tripped, and she fell, and my mother didn't ask her how she was. She asked her, "Did you tear your stockings?"

LAURA: In the '40s and '50s, you went to the stocking counter. There were always one or two lovely older women, and they would get the stockings down from in back. They were all in rows, and one woman would take them out and put her hand in. "Do you like these?" You go to buy a pair of stockings now, and no one ever helps you. It's so different shopping—when you think about it.

THE ISABELLA FREEDMAN JEWISH RETREAT CENTER

The First Hundred Years

Avital Rech

The forerunner of the Isabella Freedman Jewish Retreat Center was founded in 1892 as the Jewish Working Girls Vacation Society by Selena Ullman Greenbaum, the first president and director. At that time, several fresh-air charities existed for working girls in New York City, but many had upper age limits, and none offered Jewish girls an option where they could follow Jewish dietary laws.

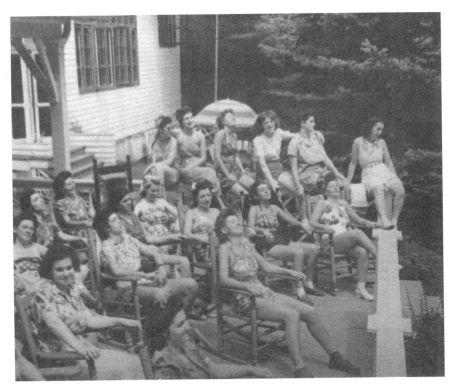

"Jewish Working Girls" enjoying their vacations at camp, circa 1930s. *Courtesy Isabella Freedman Jewish Retreat Center.*

The Society mostly targeted girls living on the Lower East Side, many of whom were Russian immigrants. Although they were required to pay a small amount toward their vacations—usually two or three dollars a week and their carfare to the site if they could afford it—the Society reimbursed them for lost wages. Since most Jewish garment workers and shop workers at this time made between five and ten dollars a week and helped support their families, two dollars represented a significant portion of their income.

Until the 1920s, the Society rented different sites in the New York City area, Westchester County, Long Island and the Adirondacks. In the late 1920s, when Judge Irving Lehman, chief judge of the New York State Court of Appeals, donated land in Port Chester, New York, for the camp, the Society changed its name to Camp Lehman for Jewish Working Girls.

Another name change took place in 1936, when Lehman board member Isabella Freedman left $25,000 to the agency. As the mission

Senior campers at Camp Isabella Freedman, 1982. *Courtesy Isabella Freedman Jewish Retreat Center.*

of serving Jewish female workers became obsolete in the 1940s, Camp Isabella Freedman began offering coed summer vacations to young adults, including ex-GIs and students who could not otherwise afford a vacation.

In 1956, the agency moved to Falls Village, Connecticut, and began to offer programs for senior adults. These summer and Passover vacations provide Jewish seniors with opportunities to experience the rich cultural life of the Berkshires in the summer, while also enjoying fresh air and recreational and educational activities at the site.

As longtime camper Sally Hagel put it, "Where else can an older person eat kosher food, go paddle boating, go to synagogue, do an oil painting, go shopping at the outlets escorted and hear Bach at Tanglewood in the evening?" The agency provided all of this for an affordable fee, with scholarships available.

In the early 1990s, with the support of a UJA Federation of New York continuity grant, Isabella Freedman became a year-round retreat center for the Jewish communities in New York and New England, with more than thirty Jewish organizations of all denominations holding retreats there each year.

In 1994, the staff of Isabella Freedman and Surprise Lake Camp developed the Teva Learning Center. Integrating ecology, Jewish spirituality and environmental activism, Teva serves students from Jewish day schools throughout New England. During this period, Isabella Freedman also helped develop the Jewish Multiracial Families Retreat and eventually the organization.

Into the Twenty-first Century

Barbara Starr

Building on its experience with the Teva Learning Center, in 2003 Isabella Freedman developed ADAMAH: The Jewish Environmental Fellowship. A leadership-training program for young adults, it teaches the vital connection between Judaism and environmental stewardship. ADAMAH fellows live communally for six months and engage in a hands-on curriculum that integrates organic agriculture and sustainable living skills, Jewish learning and living, leadership development and community building. The program strengthens participants' Jewish identity and commitment to *tikkun olam* [repairing the world] through immersion in an ecologically sustainable, spiritually vibrant and inter-generationally connected Jewish community. It also exposes countless others to a traditionally rooted yet entirely new way of Jewish living.

In 2006, the Elat Chayyim Jewish Retreat Center merged with Isabella Freedman, becoming the Elat Chayyim Center for Jewish Spirituality. For fifteen years, Elat Chayyim has transformed contemporary Jewish life with retreat programs that integrate Jewish learning, spirituality and culture. Elat Chayyim continues to be a resource and retreat center for the development, experience and promotion of a comprehensive Jewish spiritual practice. Its retreats promote practices that draw on the wisdom of Jewish tradition and reflect the values and consciousness of our ever-evolving modern experience of Judaism. Elat Chayyim retreats offer experiential approaches to Jewish learning, ritual and prayer that help participants in their search for the divine presence in all aspects of life.

Elat Chayyim welcomes people from all backgrounds, including individuals with limited or no Jewish education, seekers who have walked other spiritual and religious paths and those who are traditionally observant. The faculty includes respected and innovative thinkers, scholars, authors, artists, teachers, cantors and rabbis from across the Jewish denominational spectrum. Thousands of people from around the world have participated in the center's weeklong, weekend and Jewish High Holiday retreats. In addition, Elat Chayyim has created unique training institutes that target Jewish professionals and provide cutting-edge programming, including Jewish meditation, yoga, chant, text study and an eco-spiritual residential community for young adults.

In January 2009, the UJA-Federation of New York launched its Network Greening Initiative to help its headquarters and more than one hundred beneficiary agencies save both money and the environment. The Isabella Freedman Retreat Center received a grant from UJA to develop and implement the Jewish Greening Fellowship, a program that aims to reduce the carbon footprints of network camps and community centers. The first cohort of twenty participants was guided through an eighteen-month course on how to green their agencies, a meaningful Jewish response to global climate change. In recognition of the positive impact this grant has had on the environment, the UJA-Federation of New York has funded the Jewish Greening Fellowship for a second cohort, which will launch in early spring 2011.

AVITAL RECH was the executive director of the Isabella Freedman Jewish Retreat Center from 1997 to 2000. She holds master's degrees from Brandeis University in Jewish communal service and nonprofit management and is now an ICU nurse at Boston Medical Center.

BARBARA STARR is the development director for the Isabella Freedman Jewish Retreat Center. See also www.isabellafreedman.org.

DANBURY'S LAKE WAUBEEKA

Cindy Mindell

The Town That Jewish Firefighters Built

On September 1, 2002, members of the Lake Waubeeka community dedicated a garden to the "heroic efforts of the pioneer fire-fighters and their wives." The memorial plaque reads: "In tribute to those members of Ner Tormid, the Jewish firemen of the City of New York who were the founders of Lake Waubeeka. They have left an indelible mark on the lives of this community. 1950."

The founders were members of the Naer Tormid society, the Brotherhood of Jewish Firefighters, founded in 1925 in New York City. The name was the mistransliteration of the Hebrew *ner tamid*, "eternal flame," by the original Fire Department of New York (FDNY) Jewish chaplain, Rabbi Edward Lissman, says society historian Steve Klein. In 1996, when Klein became the organization's president, he corrected the spelling by filing an assumed name with the State of New York.

Main Street, Danbury, Conn.

Ner Tormid's membership peaked from 1939 until the '60s, Klein says, when close to one thousand Jewish men were part of the municipal firefighting force. "A lot of them had trained as lawyers or doctors," FDNY battalion chief Paul Tauber told *Hadassah* magazine in 2002, "but joining up with the civil service was the only way to get a paycheck every week."

In 1950, a small group of members headed north in search of land to build summer homes. They discovered an old Boy Scout camp on the shores of Lake Waubeeka in Danbury, in the shadow of Moses Mountain, and purchased a large plot as Lake Tormid, Inc., in 1951. By the '70s, as the firefighters began to retire, the houses on stilts had become year-round residences. The Lake Waubeeka Association is currently the largest private landowner in the city of Danbury.

Only one of the original firefighter founders, Mac Pearlman, still lives in the community, says longtime resident and Bronx native Dave Zwang, whose parents purchased a plot of land in 1952 for $2,500. But several descendants of the "originals" live in Lake Waubeeka, whose streets are named for the founding families' children. One, Carol Street, is named for Carol Klein, who became the singer-songwriter Carol King.

While no longer strictly a Jewish community, many residents are Jewish or Israeli, and the modern Orthodox Congregation Mount Moses operates during the summer and High Holidays.

Today, some 150 of the 11,000 FDNY firefighters are Jewish, and Ner Tamid numbers 300 members, mostly retirees. The society has expanded to include dispatchers and emergency medical technicians. It is the largest in the national network of Shomrim societies, Jewish fraternal organizations affiliated with municipal public safety departments.

Congregation Mount Moses

When members of the Naer Tormid Society began building the Lake Waubeeka summer colony in 1952, they would hold Shabbat and holiday services in one another's homes. In 1957, a small group, led by brothers Barney and Al Schenker, decided to build the growing community its own synagogue. Among the founders were Hyman Holtzman, Mickey Rosenbaum, Joe Schenker and Izzy Steinbaum.

Firefighters (*from top left*: Barney Schenker, Hyman Holtzman, Joe Schenker, Izzy Steinbaum and Al Schenker) building the Mount Moses synagogue from recycled materials. *Courtesy Mount Moses.*

They named the new congregation to reflect Waubeeka's hilly terrain. Many of the building materials were remains from fires, says Mount Moses president Mitch Rothschild. Beams used for the walls were part of the Belt Parkway in New York, and the doors came from a burned-down catering hall. There was no heating system for at least twenty years. Instead of regular dues, the shul was supported by contributions. "They were a scrappy bunch," Rothschild says of the firefighters.

It's a simple and rustic building on the edge of a wooded gully, with a small foyer, a high-ceilinged sanctuary and a social room and kitchen. There are commemorative bronze plaques on the walls of the two spaces. The sanctuary's windows are patchworks of stained-glass rectangles.

The shul is still Orthodox, with the men's and women's sections separated by the central aisle leading to the bimah. Rabbi Gedalia Buchbinder first led the congregation, followed by a succession of

student rabbis hired for the High Holidays. Today, there is no pulpit rabbi, though six congregants are either current or former rabbis from all denominations. Around twenty-five families attend during the summer and High Holidays, Rothschild says.

Barney Schenker died in 2000, on a Sunday. Fellow congregants knew that something was wrong when he didn't show up for Shabbat services the day before, says Harriet Krate, Barney's daughter. The congregation hung a bronze plaque above the ark, reading:

In Memory of Barney Schenker:
Pioneer, Innovator, Man of Vision

A Torah cover was made in Barney's memory, incorporating his Fire Department of New York fire chief patch. The Torah sits in the ark and is used weekly. "We now call the Torah 'Barney,'" Rothschild says.

Cindy Mindell is a staff writer with the Connecticut Jewish Ledger. *"The Town That Jewish Firefighters Built" is reprinted with permission of the* Connecticut Jewish Ledger, *April 29, 2008, www.jewishledger.com.*

A Uniquely Changing
Community: Waterbury

They Found Their Way:
Generations of Jewish Life In Waterbury

Mattatuck Museum

The German Immigrants: 1850–1880

The earliest Jews known to have settled in Waterbury arrived in the middle of the nineteenth century as part of a larger influx of German immigrants. Many of these immigrants were affluent and educated, seeking opportunities for economic success and religious tolerance in America.

The first of these immigrants in Waterbury are believed to have settled in the Brooklyn neighborhood and the Canal Street area of Waterbury's south side. Benjamin Girtski operated a clothing store in a rented shop at Exchange Place as early as 1853. Many of the earliest arrivals were merchants. Adolph, Philip and Joseph Pollack, who came from Karlsbad in Bohemia, opened a framing shop on South Main Street. Isidore Chase, who arrived from Prussia, operated a millinery shop, also on South Main Street. The Hollanders, Mendelssohns and Levis were merchants as well.

By 1875, there were approximately fifteen Jewish families living in Waterbury, all German immigrants. The earliest arrivals had traveled

to New Haven to attend synagogue, but in 1872, Temple Israel was organized, and holiday services were conducted by visiting rabbis in halls rented in Waterbury for the occasions, including Way's Hall. Melchizedek Lodge of the Independent Order of B'Nai Brith, a Jewish fraternal association, was organized by seventy-five people in Waterbury in 1873, and the Melchizedek Burial Association bought land for a cemetery in 1875. The Hebrew Ladies' Benevolent Society, a charitable organization, was formed in Waterbury in 1876.

Immigrants from Eastern Europe: 1880–1920

The largest number of Jewish immigrants to Waterbury arrived during the first two decades of the twentieth century. More than eighty-five hundred immigrants from Russia, Poland or Lithuania settled in Waterbury during this time, including some who arrived by way of New York, Canada or other cities in Connecticut and New England. Many of these Eastern Europeans were Jews, refugees fleeing the wars of Eastern

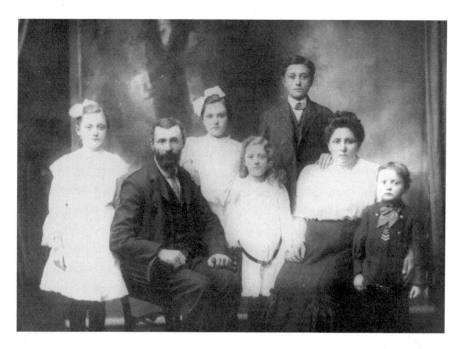

Garber family portrait, 1904. *Courtesy Collection of Donald Garber, Mattatuck Museum.*

Europe or official czarist policies in Russia to eliminate the Jewish people through economic strictures and officially sanctioned mob violence.

Most of the Eastern European Jews began arriving in Waterbury after 1880. Within a decade, there were more than sixty Jewish families in the city. These new arrivals settled in the dense commercial area at Canal Street and Chatfield Avenue, as well as Bank Street and Riverside Avenue in Brooklyn. They found work as peddlers, tradesmen, farmers and factory workers. Many built successful businesses that served their Jewish neighbors and the larger community.

Secular Jewish organizations were established in the Kingsbury Street neighborhood by the Eastern European Jews, as well as religious organizations and synagogues. The Eastern European immigrants included socialists, Zionists and atheists. Their social organizations reflected this diversity and emphasized the Yiddish language that formed a common bond among the new immigrants.

At Work

Peddlers, traders and merchants were among the earliest occupations of Jewish migrants to Waterbury, and the retail trades remained a highly visible arena for successful Jewish businesses over the next century and a half. Many Jewish immigrants, however, worked in other occupations: as farmers, bakers, tailors, jewelers, mechanics and manufacturers. Their children became teachers, lawyers, judges, writers, entertainers and doctors.

The majority of Jewish immigrants had been forced off farmlands in Europe and had become middlemen in the grain and cattle trades or became experienced village peddlers. But a number of the Jewish immigrants to the United States were still farmers or were receptive to the prospects of farming in America.

Manufacturing was the economic engine of Waterbury during the first half of the twentieth century. A number of Jewish families became part of the city's success in manufacturing and contributed to its industrial accomplishments. By the middle of the twentieth century, college-educated businessmen, some the children of local Jewish families, brought new strategies to the expansion of area manufacturers. Isadore

Cross, for example, led Harper-Leader's expansion into one of the area's leading electroplating plants. More recent generations of Waterbury's Jewish community have built careers in numerous and varied professions, and their ranks include doctors, lawyers, educators, editors, publishers, architects, accountants, musicians and nurses.

Keeping the Faith

The Jewish community in Waterbury has included immigrants of diverse nationalities, occupations, economic and educational backgrounds and political viewpoints. While these differences have produced a variety of congregations and social organizations that respond to the differing interests within the Jewish community, the common foundation of their faith has formed a bond among them all.

The synagogues in Waterbury have reflected the evolution of Jewish religious practice throughout the United States. Religious observance

Purim Play at the Hebrew Institute, Waterbury, circa 1936. *Courtesy Collection of Arnold and Dorothy Schiller, Mattatuck Museum.*

has taken several forms, among them Orthodox, Conservative and Reform. These disciplines have maintained different practices regarding appropriate dress, such as prayer shawls and head coverings; whether seating within the synagogue is segregated by gender or permits families to sit together; the use of music, Hebrew and English within the service; and other issues.

Education has been highly valued in Jewish communities, emphasizing religious training and academic accomplishment. The establishment of Jewish schools has been undertaken at the earliest stages of the organization of a congregation, with great effort made to secure appropriate scholars to teach in the schools and great respect accorded to those who serve as Jewish teachers.

The first acts recorded by Jewish organizations in Waterbury have been the purchase of land for Jewish burial. These sacred resting places have been and are protected by the descendant community, even after the original sponsors have lapsed, and remain a silent testament to the long history of the Jewish people in Waterbury.

Charity has been a hallmark of the Jewish community in Waterbury, as elsewhere. Helping those in need is an obligation of the Jewish faith. With an impressive record of charitable assistance within the Jewish community during the early immigrant years, many Jewish charities also turned their attention to modern social issues in the twentieth century. These have included the needs of Israel through the middle decades of the twentieth century, as well as the struggle for worker rights and for Civil Rights.

The Third Generation—and Beyond

Beginning in the 1920s, many younger Jewish families moved to the larger homes with yards and parks where children could play in the Cooke Street and Overlook neighborhoods.

As the children of the second and third generations went away to college and served in the military during World War II, they became part of larger social communities. They became engaged in international Jewish issues to a greater extent than the previous generations. Returning to Waterbury, they brought new perspectives to the practice of their faith and a new sense of their relationship to the traditional Jewish community.

Many families in this generation moved to the suburbs west of Waterbury [particularly Southbury and Middlebury], although the Cooke Street neighborhood remained a center for others. By the second half of the twentieth century, marriages beyond the local community, and outside the faith, were increasing in frequency, leading to new interpretations of Jewish traditions. By 1970, the city of Waterbury had 2,500 Jews in a city population of 112,000—fewer than the number of Jews who had lived in the city fifty years earlier.

Waterbury's Jewish community has continued to assist Jewish immigrants throughout the twentieth century. Synagogues and the Jewish Federation welcomed Jewish refugees and Holocaust survivors after World War II and helped find homes here for Russian Jews released from the Soviet Union in the 1980s.

The newest immigrants to Waterbury's Jewish community are associated with Yeshiva Ateres Shmuel, which has brought hundreds of people to the Overlook neighborhood to worship in the synagogues and to study in the Yeshiva, housed on the University of Connecticut campus on Hillside Avenue.

This article is excerpted from the online exhibition "They Found Their Way: Generations of Jewish Life In Waterbury, CT," courtesy of the Mattatuck Museum. Jewish History Project chairperson, Audrey Walzer; project coordinator, Marie Galbraith; historian, Ruth Glasser, PhD; exhibit script, design and production, Ann Smith and Raechel Guest. See also www.mattatuckmuseum.org/collections/jewish_history_project/index.htm.

Transition: Revitalizing the Community

Rabbi Judah Harris, as told to Adam M. Shery

In late 1996, Dr. Michael Blumenthal, a history professor at the University of Connecticut, who was a longtime customer in my wife's New Haven antique store, came into her shop. He had a sad look on his face. He explained to my wife that he was a former president of B'nai Shalom Synagogue in Waterbury, which had fallen on hard times because it

was literally a dying congregation, most of whose members were in their seventies or older. Therefore, the shul was looking for a part-time rabbi since it could no longer afford a full-time rabbi. My wife told Dr. Blumenthal that I was a nonpracticing ordained rabbi who conducts High Holiday services and she would recommend me to solve his problem.

Upon being hired, the first life-cycle events I performed were all funerals. One of them was in November 1997 for ninety-year-old Harry Zeiger, whose son, Allen, a professor of medicine at the University of Pennsylvania, was sitting shiva for his father. He told me that thirty years before then, Scranton, Pennsylvania, was a dying community like Waterbury. It was revived when a yeshiva [a school for advanced religious study] was established there, which attracted Orthodox Jews.

He then gave me a piece of advice, which, when I followed it, transformed the community from impending death to healthy growth: "If you can bring an Orthodox yeshiva to Waterbury, people would come here. The community would be revived."

He encouraged me to speak to Harav Bressler, the Rosh Yeshiva [dean] in Scranton who said I should speak to Torah Umesorah, which is a national Jewish education organization that encourages and promotes Jewish education.

Torah Umesorah asked me to come to Manhattan on February 12, 1998, to tell them about Waterbury. I told them homes were very affordable, very inexpensive and could be bought for about one-quarter of what the cost was in Brooklyn. It was ideal for the large families that typify the Orthodox Jewish community.

Torah Umesorah sent philanthropists to Waterbury, which had an Orthodox but declining shul and a *mikvah* [ritual bath]. The Conservative synagogue, Beth El, was already moving away, and it had an auditorium that could be used by a yeshiva, as well as a *beis medrash* [study center]. It also had a classroom building. They decided to buy ten houses and the Conservative synagogue to provide housing for a planned yeshiva faculty and a facility to house the yeshiva.

The most important thing in the development of the yeshiva was by coincidence. The parsonage that I lived in was next door to the home of Cherrie Roland, the mother of the governor of Connecticut, John Roland. I told her that if we had a big facility that had an auditorium,

classrooms, libraries, the yeshiva could really expand beyond what Beth El could provide. Through her introductions, I was able to convince her son and Mayor Giordano to promote the transfer of the UConn campus by long-term lease to the yeshiva and to move the existing facility to its current downtown location.

The campus now houses the day school of the yeshiva and its administrative offices. All told, more than one hundred families moved into Waterbury since the yeshiva opened in the year 2000, and because of their large families and the international reputation it now has in the "yeshiva world," close to four hundred students are attending its four schools.

The original motivation for reviving the community—the reversal of fortune for the dying synagogue—has been fulfilled. There are now well-attended religious services every morning and evening, on Sabbaths and holidays, as well as popular adult classes for a membership of over one hundred families. Michael Bluementhal is no longer seen with a sad face.

Yeshiva students studying in the *bais medresh*. *Courtesy Yeshiva Ateres Shmuel.*

Rabbi Judah Harris served as the part-time rabbi of B'nai Shalom Synagogue from January 1997 until his retirement in 2006. His full-time job was as a lawyer in the attorney general's office in Hartford until his retirement in 2009. Adam M. Shery is a graduate student in history at American University.

Yeshiva Ateres Shmuel of Waterbury

Rabbi Aaron Sapirman, as told to Betty N. Hoffman

I was born in Toronto, Canada, and I live in Waterbury, Connecticut. Most people in Toronto, Canada, before the year 2000 had never even heard of Waterbury, Connecticut.

I actually was learning in Detroit, Michigan, and I was very happy there. I had graduated that summer of 2000 and was going to go back there for post–high school. I didn't even know about this place.

Rabbi Ahron Kaufman—his son was a camper of mine—came to say hello to his kid in camp. As I walked over to him, he looked at me and said, "If this is about the yeshiva, call me on Wednesday."

I didn't even get to introduce myself. Less than an hour later, I got a message from the office at the camp that my dad wants to talk to me. I call my father. He said, "I just heard about a new yeshiva opening with Rabbi Kaufman as Rosh Yeshiva. They're looking for boys to go, pioneer."

That Wednesday, I made the phone call, but Rabbi Kaufman was so busy that we couldn't get though. So I called my sister-in-law's parents, who lived across the street, and they brought the cordless phone, knocked on the door and handed Rabbi Kaufman the phone. That Sunday, I got on a flight from Toronto to Hartford, and the rest, as they say, is history.

Why did it happen? Why did we end up here?

In August of 2000—how it all came together was nothing less than the hand of God—thirty-one individual students came together under one roof to begin a yeshiva. Nine families joined them. Some were from Israel; some were from New Jersey; some were from Brooklyn, from wherever they may come from.

There were no kids really because there were no schools. We had to create our own. I think we had two or three kids in the class. The second

year, the class became official. It was just so amazing to look and say, "Hey! There's a class of young kids learning Torah, learning the *aleph-bais* here in Waterbury."

When you plant a tree, you know that a tree will grow because that's the nature of the seed, but you plant a spiritual seed, sometimes we don't know what will take place. You have no idea. Ten years ago, we planted a spiritual seed that has exploded.

I say it's unique because we never knew each other, because there's so much diversity. There's no difference between a black hat [ultra Orthodox] and a *kipa srugah* [modern Orthodox]. There's no difference between a Sephard and an Ashkenaz. To us, we're servants in the army of HaShem. Anybody who wants to join is more than welcome. If you see a For Sale sign, grab it. There's no board of entry. You don't need a passport to move here.

Throughout these past ten years, the yeshiva has seen that its growth depends on the community, and the community has realized that its growth depends on the yeshiva. The one can't exist without the other, which is literally the beauty of what takes place here, because everything that we do is intertwined with the word of God. Everything dates back to "What did the Torah say?" How do we live our lives? Before anybody takes a toaster out of the box, they always read the instructions. The Torah is our book of instructions.

Here we have an incredible education system that allows a family to come in with any age children, and we have a high level of education to provide for them. But that took time. Now we have Yeshiva K'tana—nursery through eighth grade. We have Mesivta, the high school for boys. We have Yeshiva post–high school, college, kollel for married men.

We started here with 31, and ten years later we have 520 alumni. Think of how many boys have been affected by this institution, have come through the institution, of how many people hold this institution in their hearts.

It's all here. This place was sitting here and waiting for us. You talk about a magnificent park with ball fields, and a pond, and a spring and a place for the kids to play just sitting there across from the yeshiva. I don't want to sound too cutesy, but the same way a kid would be sitting in his playroom, imagining if he had to build a city for himself—that's literally what HaShem did for us. He put this here, and he put it here vacant. He put the shul up for

Children playing on the Yeshiva K'tana playground. *Courtesy Yeshiva Ateres Shmuel.*

sale. He put the park across the street; he put the housing low and cheap. He put the shopping—there's a mall five minutes away from here. There's no other way to define, not why we succeeded, but how we were able to succeed. What you have here literally is the Hand of God.

I am living here with my wife and two children, thank God, and many of my friends have done the same. We have made Waterbury not only the place to live, but we have made it our home. Waterbury is in our hearts. Waterbury is the bloodline that goes through our veins. It has been woven into the tapestry of who we are and the history of who we will become. To say that it is something special to us is an understatement. Waterbury is not special to us. It is us. This is what we are. We built it. The walls know that we built it. It can only get better.

RABBI AARON SAPIRMAN is a graduate of the first class of what was then called the Yeshiva Gedolah of Waterbury. He is the cantor at B'Nai Shalom and is on the administrative staff of Yeshiva Ateres Shmuel.

NEW HAVEN:
YIDDISH AND YALE

TOWN AND GOWN CONNECTIONS

Dr. Barry E. Herman

It is believed that the first citizens of Jewish origin in New Haven—founded in 1638—were the brothers Jacob and Solomon Pinto, who settled there in 1758. With the outbreak of the Revolutionary War, the three sons of Jacob Pinto—Solomon, Abraham and William, all students at Yale—took up arms in George Washington's Continental army and fought with distinction. In 1783, Jacob Pinto was a signer of the petition to the Connecticut General Assembly, which brought about the incorporation of New Haven as a town.

Founded in 1701, Yale focused on training men to become Protestant ministers. The theology curriculum included the three classical languages: Greek, Hebrew and Latin, with the latter two included on the Yale seal. The Hebrew *urim v'tumim* translates as "lights and perfection."

According to Dan Oren, author of *Joining the Club: A History of the Jews and Yale*, many of Yale's early presidents would give lectures in flawless Hebrew. One of these was President Ezra Stiles (1778–95), who recorded in his diary the arrival of an unnamed Venetian Jewish family composed of eight to ten Jews in the summer of 1772. Stiles noted that they observed the Sabbath in the traditional Jewish manner,

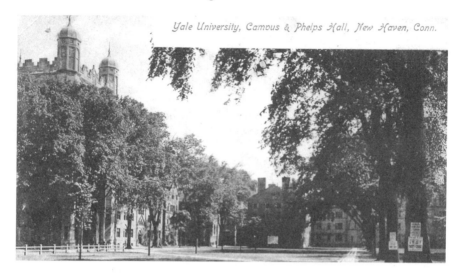

Yale University, Campus & Phelps Hall, New Haven, Conn.

"worshipping by themselves in a room in which there were lights and a suspended lamp." Stiles also stated this was a private Jewish worship since the Jews were too few to constitute a synagogue minyan (ten men), "so that if thereafter there should be a synagogue in New Haven, it must not be dated from this."

An early Jewish student, who was only fourteen when he enrolled at Yale in the 1820s, was Judah P. Benjamin; he later became a United States senator and secretary of state for the Confederate States of America. Why he left Yale and never graduated is still a mystery.

The first Jewish house of worship in New Haven was established in 1840, founded by Jewish families from Bavaria. Congregation Mishkan Israel was the first Jewish congregation in Connecticut and the second in New England. The early German Jews distinguished themselves as merchants, civic leaders and professionals. Some of these early families included the Adlers, Bretzfelders, Lehmans, Lauterbachs, Milanders, Ullmans, Watermans, Rothschilds and Zunders. Michael Milander was the first reader at Congregation Mishkan Israel and the first paid Jewish official in New Haven.

Leopold Waterman was the first president of Mishkan Israel, and his brother, Sigmund Waterman, a part-time instructor of German from 1844 to 1847, was the first known Jew to teach at Yale. Sigmund was also the first Jewish doctor to graduate from Yale in 1848. Both brothers were leaders in the New Haven Jewish community.

One of the many kosher businesses in early twentieth-century New Haven. *Courtesy JHSNH.*

From 1880 to 1920, New Haven's Jewish population grew rapidly with a great wave of Eastern European Jews from Russia, Poland, Ukraine, Lithuania and Romania fleeing the pogroms taking place in the Russian Empire. Many moved into the Oak Street (later called Oak Street/Legion Avenue) neighborhood, where they created a community, opened businesses and founded a variety of charitable, educational and social organizations. Over a dozen new synagogues were started during this time. By the outbreak of World War I, the Jewish population had increased to about twenty thousand.

In 1917, New Haven had its only Jewish mayor, Samuel Campner, a prominent attorney. When Mayor Rice suddenly died in office, the city charter stated that the president of the New Haven Board of Aldermen—the position then held by Campner—would become mayor.

In 1903, a chapter of the New York–based Arbeiter Ring/Workman's Circle brought secular Jewish socialism to New Haven. A mutual aid

Factories in the Jewish neighborhoods provided work for New Haven's immigrants. *Courtesy JHSNH.*

society with deep Yiddish cultural roots, the Workmen's Circle attracted skilled craftsmen, factory workers and other members of the working class. It provided mutual assistance, a forum for radical ideas and Yiddish cultural activities and events.

The main institutions associated with the diverse branches of the left—including the International Workers Order, a splinter group of the Workmen's Circle—were the Labor Lyceum, the Kinderscule for children, the Freiheit Chorus and the Young People's Socialist League (YPSL), founded in 1916 by high school students. The educated Yipsels, however, saw socialism within its American context, an approach categorically different from that of their immigrant proletarian parents. While some of the Yipsels later moved into general socialist circles, eschewing even their culturally Jewish backgrounds, others bought into the American dream, continuing their educations and moving into the rising Jewish middle class.

As a group, the immigrants were eager for their children to receive good educations, with Yale, the local college, as the goal for many. However, a quota system limited the number of Jewish students, no matter how intelligent or promising.

Although Dr. Lafayette B. Mendel, considered to be the "Father of the Vitamin," was the first Jew to receive a full-time appointment to Yale University in 1896, it was not until 1943 that Professor Rollin B. Osterweis, a distinguished historian and author, became the first full-time instructor at the undergraduate division, Yale College.

Yale's well-documented quota system continued into the 1960s, when President A. Whitney Griswold, under pressure from Jewish leaders and Yale alumni, ended this discrimination. In 1965, William Horowitz (Yale, 1929) became the first Jewish member of the Yale Corporation, the governing body of the university. The election of this distinguished New Haven banker and Jewish community leader paved the way for women, Catholics and blacks to become members of the Yale Corporation.

Dr. Richard Levin, Yale's first Jewish president, has served since 1993. Today, Jewish students make up about 30 percent of the student population, and there have been hundreds of Jewish faculty members and administrators and thousands of Jewish alumni.

After World War II, a small wave of Holocaust survivors settled in New Haven. In 1977, this group spearheaded a drive to build a Holocaust memorial. Located on Whalley Avenue, across from the Mishkan Israel Cemetery, the New Haven Holocaust Memorial was the first of its kind in the nation to be built on public land. Also, housed in Yale's Sterling Library—along with an extensive collection of Judaica in many languages—is the Fortunoff Video Archive of testimonies of and recollections from Holocaust survivors and witnesses.

In the 1980s, a large number of Russian Jewish families came to the New Haven area from the then Soviet Union. Today, Greater New Haven's Jewish population is estimated at around thirty thousand people.

DR. BARRY E. HERMAN is a professor of education at Sacred Heart University in Fairfield. He is the author of eight books and has had 185 articles published in leading educational journals and magazines.

SELMA B. ROSENTHAL'S MIDWIFE'S LEDGER

Dr. Barry E. Herman

Finding a midwife's ledger dating back to the late nineteenth century was like winning the lottery or digging up a buried treasure in your own backyard. When I was an administrator in the New Haven School System, Lillian Rosenthal Palmisano, a school secretary, showed me a midwife's ledger belonging to her grandmother, who recorded births of New Haven children from 1889 to 1910. The ledger was written in a beautiful clear cursive script. There were eighty legal-size pages with 664 birth entries.

The State of Connecticut required midwives to keep carefully detailed notes and information about each delivered birth. Each entry mentioned the full name of the newborn child; his/her date of birth; parents' names, first and last; ages of parents; father's occupation; family address; number of children born to mother; and number of living siblings. Fees paid ranged from one dollar per delivery to seven dollars. Mrs. Rosenthal lists her midwife's earnings from 1892 at $339.25.

During the years recorded in the ledger, there were 138 babies delivered by Mrs. Rosenthal to families living on Oak Street [in the Jewish immigrant neighborhood]. Mrs. Rosenthal's expertise as midwife also brought her to other areas of the city and the surrounding suburbs: Tyler City, Orange, Hamden and Westville.

I found twenty girls named Marie, born of both Jewish and non-Jewish parents. The second most popular name was Rosie (eighteen), followed by Sarah (eleven), Fannie (ten), Leah (eight), Ida (eight) and Esther (seven). Some very distinctive Italian female names included: Beppina, Azzunta, Augelina, Carmen, Jiovanetta, Francesca and Theresa.

Male first names were most decidedly of biblical or Old Testament origin. There were fifteen boys named Abraham; eleven Josephs; nine each of Moses, Michael and Jacob; seven Judahs; and five Isaaks. The ledger lists only seven Davids, a surprise because for the past thirty years, David has been among top five most popular names for boys. The most popular names were Harris and Louis, tied at sixteen.

The ages of the mothers when they had their children could be an almost perfect bell-shaped curve, with the mean falling in the twenty-

seven to thirty-five age bracket for most of the children delivered by Mrs. Rosenthal. There were seventeen mothers under twenty and seventeen mothers over forty.

The occupations of these immigrant fathers fall into several categories. The Jewish men tended to be tailors, shoemakers and shoe dealers, merchants, peddlers, needle tradesmen, salesman, shopkeepers and skilled artisan workers.

It should be noted that Poland was not an independent country in the nineteenth century, so people could give Poland, Russian Poland or Austria, which controlled southern Poland, as country of birth. It is also true that Russia could mean the Russian Empire, which encompassed the Ukraine, White Russia, Estonia, Lithuania and Poland. This area was called the "Pale of Settlement," where the majority of the Jews lived in the empire. The information in the ledger clearly reveals that the largest number of fathers was born in Russia (329), with Italy (90) in second place.

This article was adapted with permission from "Selma B. Rosenthal's Midwife's Ledger of Births: 1889–1910," Jews in New Haven, *Vol. VII. Werner Hersch and Lillian Rosenthal Palmisano assisted with the research for this article.*

BAGELIZING AMERICA: THE LENDER FAMILY

Andrew Horowitz

Over the course of the twentieth century, members of the Lender family of New Haven have distinguished themselves as business innovators, cultural ambassadors, community leaders and international philanthropists. They invented the frozen bagel, helped popularize Jewish culture in America and have made substantial contributions to their local and global Jewish communities.

Harry Lender was born in Chelm, Poland, in 1895. When he was twenty years old, he moved to Lublin, Poland, where he married Rose Braiter and opened a bakery. Harry and Rose had three children in Lublin: Hymen, Sam and Anna.

Rising anti-Semitism encouraged the family to leave Poland, and in 1927, Harry immigrated to America. He moved first to Passaic, New Jersey, where he found work in a bagel bakery and learned the bagel business.

In 1929, he bought a bakery on Oak Street, the Jewish hub in New Haven, and sent for the rest of his family. In 1934, the family and the bakery—named the New York Bagel Bakery—moved to Baldwin Avenue in the city's Hill section. In their new home, Harry and Rose had three more children: Murray, Helen and Marvin.

The bakery thrived on Baldwin Street, making bagels for an almost exclusively Jewish clientele. By the mid-1950s, with the Lender sons working alongside their father, the bakery produced six thousand bagels a week, distributed to local delis and bakeries on Sunday mornings. The

Courtesy JHSNH.

schedule meant that the Lenders worked excruciatingly difficult Fridays and Saturdays trying to get the bagels ready for Sundays.

In 1954, the brothers came up with the idea of making the bagels earlier in the week and freezing them, allowing a steadier work schedule. The process, which they kept secret for two years so as not to alienate skeptical customers, succeeded, allowing the Lenders to become more ambitious. Soon, they were selling frozen bagels regionally to places like the Concord Hotel in the Catskills. At the same time, the family started packaging their bagels in polyethylene bags, a process that increased the bagels' shelf life and allowed the family to start selling their bagels in supermarkets—under the new name Lender's Bagels.

Because bagels were alien outside the Jewish community, if the Lenders wanted to reach a wider market, they had to embark on a mission, as Murray put it later, "to bagelize America." For decades, Murray led advertising campaigns to teach non-Jews about the "roll with a hole": green bagels for St. Patrick's Day, an oval bagel for President Lyndon Johnson to eat in the White House, appearances on the Johnny Carson show. Murray pioneered "cross-couponing," advertising bagels with cream cheese, to teach new audiences how to schmear, and with orange juice, to teach them to eat bagels with breakfast. As his good friend Stuart Grodd put it, Murray was out to "change the breakfast-eating habits of the Christian world." The hungry audience kept growing.

While Murray worked as the public face of the company, his younger brother, Marvin, served as the "inside guy," inventing and reinventing the bagel factory several times over to keep pace with the demand Murray created. In 1965, the Lenders bought a factory in West Haven, five times the size of their bakery on Baldwin Street, and kept expanding. By 1984, the Lender Bagel Bakery had over six hundred employees and sold 750 million bagels a year. The Lenders were responsible for nearly 90 percent of bagel sales in America. When Sam Lender heard his brothers had shipped fifty cases of bagels to a supermarket in Arkansas, he knew they had made it: they had "crossed the ethnic line."

In 1984, the Lenders sold the bagel business to Kraft—presented to the media as a marriage between "Len," a Lender's Bagel, and "Phil," (Kraft) Philadelphia Cream Cheese—and turned their attention to philanthropy. The family had long been active in the Greater New

Haven Jewish community: Harry and Rose took their family for summers in Woodmont, the so-called "bagel beach" in Milford, where Jews congregated. In the mid-1970s, Marvin and his wife, Helaine, helped found the Orange Synagogue, the precursor to today's Or Shalom.

After the Lenders sold the business, Murray started a local chain of bagel restaurants—H. Lender's, named after his father—and led an effort to reinvent the Jewish Community Center of Greater New Haven, supporting the construction of a large new center in Woodbridge. He served on the board of his alma mater, Quinnipiac University in Hamden. With Marvin, he helped found the Holocaust Prejudice Reduction Education Program.

Marvin, meanwhile, set his sights outside Connecticut. While also serving in leadership positions at Yale–New Haven Hospital, the major institution in the family's old neighborhood, and along with many other philanthropic and community commitments, Marvin rose through the ranks to become president of the United Jewish Appeal from 1990 to 1992. In that capacity, he raised nearly $1 billion to fund Operation Exodus—the massive, hasty resettlement of over a half million Jews from the Soviet Union to Israel. In doing so, he played an important role in reshaping world Jewry.

Through it all, the Lenders remained a fiercely loyal and close-knit family, connected to their friends from Oak Street and the Hill. They credit their success to the vision and values of Harry and Rose. "I guess I go back again to ancestry," Sam Lender reflected once. "We all learned something and it never left us."

ANDY HOROWITZ is a PhD candidate in history at Yale University. From 2003 to 2007, he was the founding director of the New Haven Oral History Project at Yale.

KRUGER'S JUVENILE FURNITURE

Harry Kruger

In 1946, I decided to go into the hardware and appliance business. With very little money and a lot of nerve, I made the move with no previous experience in retailing. I had a great deal of support from my wife

Anita's mother, as well as my mother. Anita's mother, Rose, was quite a businesswoman, and she arranged a loan at the First National Bank, as well as the money she gave me.

With the confidence everybody had in me, I purchased a tenement house with a store for $6,500. I spent the entire summer remodeling the store. I personally built all the shelves and counters. This was my start in business at 903–5 Grand Avenue. After a storefront facelift and stock purchase, I was open for business. My receipts for the first week were $300. I ran all the way home to show Anita (I had sold my car to buy stock) how much money we took in. We jumped for joy.

The boys were now coming home from war. I figured a population increase would result in a demand for baby furniture. Factories were on a strict allotment, especially the name brands. At the time, Collier-Keyworth carriages and Colgate mattresses did very little business in New Haven, as they were not name brands. After three to four years, I was outselling all the name brands, and my juvenile furniture increased to such a degree that I phased out all hardware and appliance merchandise.

I purchased my first truck from George Greenberg, a neighbor furniture dealer, for $100. I built a van body for it, as I would for two additional trucks as time passed. In three years, I purchased a large furniture store from George Greenberg for $30,000.

My father retired from the moving business and helped me in the store. Anita helped me in the store as best she could. She would do all the housework and then put Freddy and Diane in the wicker stroller (at that time they were two and four years of age) and push them from Goffe Street to Grand Avenue, over three miles. The last block was all uphill, which was no easy task for her. But this was Anita, always there. I could never have accomplished the things I did without her.

It was in 1959 that New Haven began heating up with redevelopment fever, and we were caught in the middle. Directly across from our store, 912 Grand Avenue, we owned property containing a sporting goods store. With our purchasing additional land adjacent to our property at the then price of seventy-five cents per square foot, we were able to build our new store.

In 1961, the city was giving me a very trying time with regard to how the building was to be built, and what "they" thought would be a good

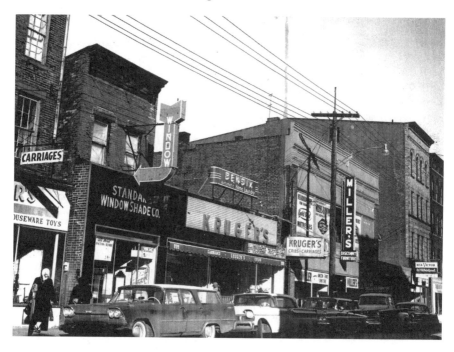

Grand Avenue, the home of numerous Jewish furniture stores, including Kruger's Juvenile Furniture. *Courtesy JHSNH.*

building, with excesses I didn't need, but we finally compromised. With all our plans finalized and before building, we closed our store and went on our first vacation in twenty years, a motoring trip for two and a half months, covering most of the United States and Canada.

In 1962, our store was built, all concrete reinforced with steel, fifty feet by ninety-five feet, the ceilings both in the store and below twelve feet high. The main floor in the store was six inches of reinforced concrete, built to withstand any kind of strain. The cost of the construction was $65,000, including air conditioning. The following year, our business increased tenfold. We were on our way and very happy with our new store.

[By the late 1960s,] I was beginning to have problems with employees at the store. They refused to work Thursday evenings and could not be counted on to make deliveries when promised. This was very upsetting to me, as our business was built primarily on service. After carefully consulting with Anita and our accountant, we decided to give up the

business, after twenty-five years. It wasn't long before other furniture stores followed our lead and decided to call it quits. On May 1, 1970, I retired from business, took a vacation on the Bahamas Islands.

After retiring, I became restless and took a position with Saab as parts coordinator on a temporary basis. My experience there varied with a different perspective as to labor vis-à-vis management. I, being in management for over twenty-six years prior to coming to Saab, found myself as a Teamster Union employee and "on the other side of the fence." (PS: I was to stay with Saab eleven and a half years, which I found to be very enjoyable. On July 11, 1982, I retired).

During the Depression, HARRY KRUGER traveled around the country doing odd jobs. He sang with a band, worked as a masseur and was a parimutuel clerk at a dog track. In 1941, he married Anita Joseph, who owned her own business, the Anita Shoppe, in New Haven.

TOWN AND COUNTRY: EASTERN CONNECTICUT

NEW LONDON AND NORWICH

Jerry Fischer

New London

The first Jew to land in the port of New London might have been John Carsen, a Dutch Jew (probably Sephardic) who chartered the brigantine *Prosperous* and was tossed in jail for violating a law that prohibited selling non-English goods in the colonies. He claimed English birth and was released from prison.

Although Naphtali Hart Myers, a Jewish merchant from New York, bought a plot of land near Mill Pond in 1761 and sold it in 1769, permanent German Jewish residence in New London did not begin until 1860, when Joseph Jacob Schwartz, an immigrant from Prussia, and his family settled in the city. Frederick, their second child, was the first Jewish child born in New London.

By 1892, enough Jews from Eastern Europe had arrived to establish Congregation Ahavath Chesed and purchase land for a cemetery. The early Eastern European Jews came from Lithuania, and a subsequent wave came from the Ukraine. While at first worshipping together at

New London. *Courtesy Jerry Fischer.*

Ahavath Chesed, the Ukrainian Jews established a second Orthodox congregation, Ohave Sholom, in 1911. It eventually merged with the Conservative congregation, Beth El, which held its first services in 1924. In 1951, when Beth El outgrew its central city location, it opened a new building on Ocean Avenue in Ocean Beach, near the new Jewish residential area.

In 1901, the New London Hebrew Ladies Aid Society was organized, with Ida Lubchansky as president and Ruth Soltz as vice-president. It was the Jewish community's social service vehicle, giving aid to the needy, sick and aged in New London and bringing holiday gifts to patients in the Norwich State Hospital, the Sanitarium at Uncas-on-the-Thames.

A number of Jewish farmers, living near larger towns in the area, sought jobs there to supplement their incomes. While some found work using their European skills as tailors or butchers, others went into the factories. Still others, including the Gruskins and Schneiders, who opened hardware stores in New London, left their unproductive farms completely.

Because of a strong naval presence, New London was an important center for the Jewish Welfare Board, with its headquarters dedicated in 1917 by Rabbi David de Sola Pool of New York. According to the *New London Day* newspaper, "The general public and men in uniform, Jewish as well as non-Jewish" were invited to attend and hear a sermon by resident chaplain Rabbi Maxwell Silver on "The Inspiration of Judaism."

The resort area of Neptune Park, near Ocean Beach, attracted many Jews from Springfield, Massachusetts, and Hartford. A small "summer shul" on Park Street, Temple Israel (1924), continues to provide summer residents with an Orthodox service. It was led for many years by the late Rabbi Isidore Greengrass, a Holocaust survivor who taught at Beth El and led services in Hebron and other surrounding small synagogues.

On March 23, 1933, the German parliament passed the "enabling law," essentially establishing Hitler as the legal dictator of Germany. The *New London Day* reported on March 28:

New London's Ocean Beach. Natalie (Ratner) Ziplow stands in front of the clock tower, 1946. *Courtesy the Mendelson family.*

Members of the Catholic and Protestant denominations, as well as Gentiles of other creeds, joined with the Jewish community of New London and vicinity at a mass meeting at Bulkeley Auditorium to protest against persecution of Jews under the Hitler regime in Germany.

The *American Jewish Year Book of 1899–1900* mentions the existence of a Chovevei Zion (Lovers of Zion) chapter in New London, and Zionist activities, spearheaded by Morris and Goldie Mallove, continued to be an important part of the town's life. In 1913, Morris Mallove, a jeweler with a retail store on State Street, founded B'nai Zion, or Sons of Zion, and became one of the key leaders of the Zionist movement in Connecticut.

On June 24, 1915, after Ruth Soltz attended a Zionist conference in Boston and heard Henrietta Szold speak, she established the B'not Zion (Daughters of Zion) club, which became the New London Chapter of Hadassah, one of the first chapters of Hadassah in the United States. During World War I, Vladimir Jabotinsky spoke at the New London Opera House, where he recruited four young men to join the newly formed Jewish Legion in Palestine.

After World War II, Harold Weiner and other young Jewish leaders helped supply matériel for Israel's War of Independence by gathering war surplus supplies and loading them onto a boat that sailed out of New London to Palestine. On November 18, 1948, six months after the founding of the state of Israel, the general and Jewish community of New London gathered at the Lighthouse Inn to honor the Malloves for their Zionist leadership.

The Jews of New London became a thriving commercial core of the downtown area, owning many of the retail stores. For many years, they took out an advertisement in the local paper, the *Day*, advising patrons that their stores would be closed for Rosh Hashanah and Yom Kippur. Because so few people would come to shop downtown on those days, many of the other stores closed as well.

In 1960, the Jewish community of New London saw the establishment of a third stream of Jewish religious practice with the opening of Reform Jewish religious services at the Mohican Hotel. This congregation would, after a time in Groton, eventually establish a permanent home in Waterford as Temple Emanu-El.

In 1971, the Jewish Federation of Eastern Connecticut assumed many of the roles of the Zionist movements, as well as serving as a social welfare and coordinating body for the Jewish community. It resettled hundreds of Jews from the former Soviet Union and plays a role in the voluntary social welfare system of the city.

The community's ties to Israel were further strengthened through Project Renewal, Partnership 2000 and the work of Sigmund Strochlitz, a major fundraiser for Haifa University. A Holocaust survivor, Strochlitz was also a key leader in the Holocaust survivors' movement to memorialize the Shoah through official state and federal ceremonies.

Norwich

As in New London, the founders of the Jewish community of Norwich were German Jews. The first recorded Jew, Adolph Chomansky, was listed in 1851 as a seller of cloth and clothing. In 1875, David Rosenblatt was listed as a weaver in Yantic.

Beginning in the 1880s, Russian Jews begin to arrive, often by way of agents who would meet boats—bearing immigrants—to recruit laborers for the mills and foundries that were the industrial heart of the city. The

The Yantic Woolen Mill.

minutes of the First Hebrew Society in 1882 note the "destitute condition of Russian Jews in Taftville." The first Russian Jews were Lazar Markoff and his brother: "one was a learned scholar who became a farmer, the other had a grocery store on Water Street." In 1895, Bernard Herman Cohen moved to Norwich with his family and became the first "official" Hebrew teacher in the city.

After the founding of the First Hebrew Society of Norwich in 1878, an Orthodox congregation was organized on High Street. The Russian Jews established a second congregation in 1883 and a burial society that purchased land for a cemetery at Brewsters Neck in Preston. In 1884, Kive Lahn won the bid to name the congregation Brothers of Joseph after his son, the first son of a Russian Jew to be born in Norwich.

Jews had difficulty securing loans from the local banks, and in 1911 a free loan association was established by Charles Slosberg, with a $400 donation made by his father, Michael. The Schlossbergs/Slosbergs were to become successful businessmen in Norwich and part of the fabric of the entire community. The family of eleven children of Moshe and Ruchel Schlossberg spread out throughout New York and the Northeast, with a number remaining in Norwich.

In New London, the family sold grain to the numerous Jewish farmers in the surrounding areas, eventually establishing the Yantic Grain Company, which diversified and opened a series of markets, the Universal Food Stores. Parts of the family also went into the scrap iron and waste business, collecting, for a fee, the "shoddy" or cotton waste from the mills and selling it to General Electric in Worcester for insulation for the copper wire the company was manufacturing there. During World War I, the demand for cotton and wool rose, and the business, Max Gordon Company, became the largest cotton and woolen waste company in the world.

In 1909, Rabbi Joseph N. Rosenberg came to serve the Orthodox Brothers of Joseph synagogue in Norwich. He was sustained by his family's wealth and never, for forty-two years, drew a salary from the congregation.

In 1929, several men met in Abner Schwartz's store and sent a letter to the Conservative Jewish Theological Seminary requesting a rabbi. Underwritten in large measure by Jacob Slosberg, the Beth Jacob Community Synagogue met in the United Congregational Church,

which it eventually purchased. In 1979, following the shift of the Jewish population to the outskirts of the city, Beth Jacob built a new sanctuary on the Norwich–New London Turnpike.

Zionist activities were an intrinsic part of Jewish life in Norwich, with attorney Reuben Levin active in researching titles for land there and organizing groups of buyers to purchase land in Palestine. Almost all the land purchases he organized were given to the Jewish National Fund.

Two brothers of the Meyer family, John and Marshall, became leading figures in their separate spheres. While John Meyer's business—John Meyer of Norwich—became prominent in the fashion industry, Rabbi Marshall Meyer founded the Conservative Seminary in Buenos Aires, Argentina, fought for human rights there and led the renaissance of congregation B'nai Jeshurun on the Upper West Side of New York. Both are buried in the original Beth Jacob Cemetery.

JERRY FISCHER graduated from City College of New York and received graduate degrees in ethnomusicology and musicology from Hunter College and Harvard University. He has been the executive director of the Jewish Federation of Eastern Connecticut since 1984.

CONNECTICUT'S JEWISH FARMERS

Mary M. Donohue and Briann G. Greenfield, PhD

Connecticut's Jewish farmers have been considered a novelty since they began to arrive in the 1890s. Though forbidden to own land in the Russia Empire, Jews still came to America with some agricultural skills gained through cattle dealing, tenant farming or raising cows, goats and chickens. In Connecticut, Jewish farmers moved past those basics, pioneering the adoption of foodstuffs, such as eggs, milk and broilers, that could be raised on worn-out, rocky New England soil. Tobacco cultivation also proved a moneymaker.

The most significant support for Jewish farmers in Connecticut came from Europe. Baron Maurice de Hirsch, a wealthy German-Jewish philanthropist, was a strong proponent of the Jewish "Back to the Land" movement, an international effort to resettle persecuted Jews in rural

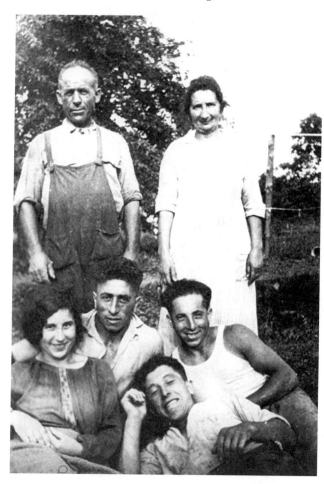

The Merkin family
(Gerson, Sarah, Lewis,
Thomas, Bernice and
Julius) on their farm,
circa 1929. *Courtesy
JHSGH.*

colonies that stressed the redemptive nature of farm life. In the United
States, the Baron de Hirsch Fund devoted significant financial resources
to the Jewish Agricultural and Industrial Aid Society (JAIAS), later
renamed the Jewish Agricultural Society (JAS).

Coming to Connecticut

Under the auspices of the JAIAS, Jews were sent to become farmers
in rural Connecticut. Early on, the organization pinpointed two areas
in which to establish independent Jewish-owned and run farms, one
encompassing the towns of Colchester and Lebanon and the village of

Chesterfield in Montville, and the other including the towns of Vernon, Ellington and Somers.

In 1908, the JAS revamped its assistance program to include four innovative pilot programs that would prove themselves essential building blocks in the success of Jewish farmers. These included the introductions of the Extension Department (responsible for a network of paid, Yiddish-speaking Jewish farm agents), the Employment Bureau that placed Jews on working farms for wages and to gain agricultural experience, Agricultural Education Scholarships for the American-born farm children and the publication of the *Jewish Farmer* magazine.

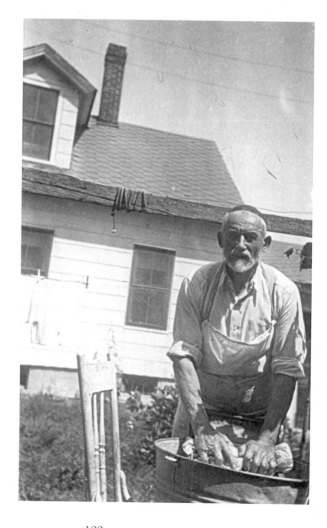

Ben Zion Dember on his farm in Colchester, 1944. *Courtesy JHSGH.*

The Jewish farmers who took to the land in the 1890s continued the subsistence farming practiced by their Yankee predecessors. They kept vegetable gardens, apple orchards and a few animals, growing crops principally for their families' consumption. But with the assistance of the JAS, they adopted a more market-driven approach that focused on intensive farming and specialized crop production made possible by new farming techniques devised through scientific experimentation. In addition, some lived close enough to towns like Norwich, New London, Willimantic and Colchester, where they could subsidize their farm income by working as tailors, shoemakers or butchers, trades brought over from the Old Country.

Community and Faith

At the end of the nineteenth century, with no ready-made Jewish farming community to step into, Connecticut Jewish farmers were on their own in constructing Jewish lives in an overwhelmingly gentile environment. Evidence of the Jewish faith of these farm families emerged in the building of places of worship. Country synagogues are found today in Columbia, East Haddam, Ellington, Hebron, Lisbon and Newtown. Two are known to have received construction loans from the Baron de Hirsch Fund: Chesterfield (lost to a fire in 1975) and Ellington. The only known example of a country synagogue found in western Connecticut is in Newtown—Adath Israel, built in 1919. Jewish farmers living along Huntington Road gave rise to the nickname of "Little Palestine" for the neighborhood.

Both before and after World War II, some Jews fleeing Europe found their way to Connecticut country locations. Their arrival increased the membership of congregations, prompting the need for larger buildings. In Hebron, these historic forces came together in a new synagogue building constructed in 1940 for Congregation Agudas Achim.

Cooperatives and Credit Unions

For protection against the vicissitudes of life, Connecticut Jewish farmers turned to traditions of collectivism and cooperation. One of the first of these efforts took hold in the Rockville section of the town of Vernon,

where Jewish farmers established a mutual aid society in 1905. In 1907, the group was reconstituted as the Connecticut Jewish Farmers Association of Ellington and developed programs to assist ill members, cooperatively purchase fertilizer, sell farm products and even provide short-term loans in cases of extraordinary need.

The JAS also encouraged its farmers to create community associations. Established by the JAS in 1909, the Federation of Jewish Farmers of America served as an umbrella organization for Jewish farm associations. By 1916, sixteen Connecticut communities had formed their own chapters. Members enjoyed social and religious gatherings, as well as lectures on agricultural science and marketing strategies.

Raising a Crop of Tourists

By the 1910s, many Jewish farmers provided lodging for summer guests. Farm families catered to fellow Jews drawn by the promise of fresh food prepared in kosher kitchens, synagogues to worship in and a respite from smoldering summers in New York City tenements. Summer shuls were constructed in Milford, New London, Old Lyme and, later, Danbury.

In Yiddish, a *koch-a-lein* ("cook for you") arrangement was typical. This meant that the guests cooked their own food in the farm kitchen or in a summer kitchen set up in another building. This allowed farmers to profit not only from collecting weekly rent but also by selling fresh ingredients to the guests.

Farm boardinghouses, providing both meals and rooms, were less common. Some places eventually developed into resorts. Famous Jewish entertainers such as Zero Mostel, a cousin of Jack Banner who built Banner Lodge in 1934 on the site of his father's farm in Moodus, traveled a Jewish summer resort circuit that included venues in New York, Pennsylvania and Connecticut.

Making a Success of It

In the decade that followed World War I, more than one thousand Jewish farm families settled in Connecticut. By taking to the land in an era of industrial expansion, these Jewish farmers bucked economic

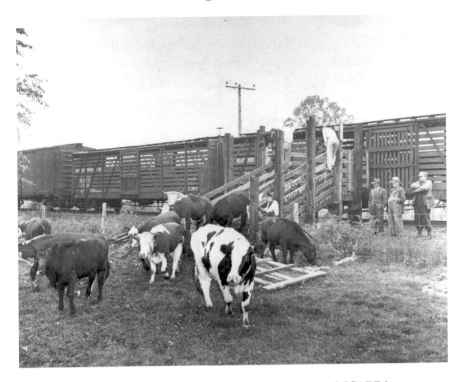

Kalmon Bercowitz (left) supervising cattle coming from Chicago to COPACO in
Bloomfield, 1930s. *Courtesy JHSGH.*

trends. Not surprisingly, many did not make it. Still, many not only
survived but also thrived.

What distinguished those Connecticut Jewish farmers who succeeded
from those who failed? In some cases, it was just good luck: a good
location with proximity to urban areas that provided a demand for fresh
eggs, milk and meat and afforded access to trolley, truck and train to
transport produce to market.

The presence of rich soils, like those found in the Connecticut River
Valley, allowed a select group of farmers in the Ellington region to cultivate
profitable tobacco crops, while important nutritional discoveries—such as
milk's vitamin A and the development of sanitary, scientifically designed
farm buildings—benefited all. The help of the Connecticut Agricultural
College at Storrs [now the University of Connecticut], where the first Jewish
student was enrolled in 1898, and the State Department of Agriculture
and its farm agents ended the farmers' isolation and kept them informed.

Jewish farmers also had a powerful ally in the JAS, which provided its own farm agents, publications and, perhaps most important, money to lend. These essentials supported individual farm families' own ingenuity and business savvy in turning old Yankee farms into flourishing dairy or poultry farms or summer resorts.

But individual success and survival is only part of the Jewish farmers' story. In many cases, these hardworking and inventive individuals revived declining rural communities and transformed the public's stereotypical images of Jews. Indeed, Jewish farming and the work of the JAS represented more than the production of food crops. Their efforts were part of an astonishing international campaign to stem the immense hardship and deprivation suffered by Eastern European Jews. Using new, creative, untried programs, the JAS helped a desperate people find a new home, country and life without sacrificing their religion.

Permission to publish courtesy of the Jewish Historical Society of Greater Hartford and the Connecticut Commission on Culture & Tourism, State of Connecticut.

MARY M. DONOHUE, survey and grants director of the Commission on Culture & Tourism, is an award-winning author. As senior architectural historian, she directs the historical research programs of the commission. BRIANN GREENFIELD, PHD, is an associate professor of history at Central Connecticut State University and the administrator of the department's public history master's program. She is the author of Out of the Attic: Inventing Antiques in Twentieth-Century New England.

"BUT SINGING, HE COMES HOME"

Rabbi Debra S. Cantor

The town of Ellington, nestled in the fertile Connecticut River Valley, is located sixteen miles from Hartford and stretches over nearly thirty-five square miles of smooth, level land to the west and rolling hills to the east. According to old real estate records, the first Jew to settle in the vicinity of Ellington was a woman named Katzenstein who purchased

land in Rockville in 1848. The earliest evidence of a Jew living in Ellington itself is a notation in town records made by Probate Judge Caleb Hopkins in 1858. Among the people buried in the Ellington Cemetery, he notes, was one woman called "Widow Sarah Jew [who] died March 23, 1807 at age 94."

The Jewish community of Ellington owes its foundation, in large part, to Baron de Hirsch's legacy. Most of Ellington's Jewish farmers, who began moving to the town shortly after the turn of the century, relied on the moral and financial support of the Jewish Agricultural Society. Samuel Levine, who composed the *Pinkas of 1905*, the Ellington Jewish community record book, in a lofty and poetic Hebrew style, described how he and his fellow Russian refugees came to be farmers in Ellington:

> *Armed with few possessions but with a strong will and a mighty spirit, we searched for a place to settle and through the goodness of God, Samuel Becker chose this place—the Connecticut River Valley—and purchased land for us here with individual dwellings—houses, barns and cattle grazing on lovely fresh green pastures—in the vicinity of Rockville/Vernon/Ellington.*

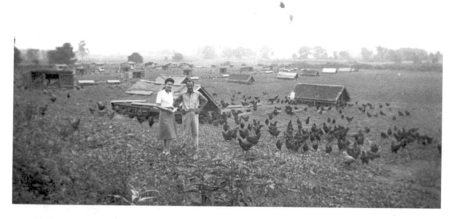

Chicken shelters on the Rashall and Cantor farm. *Courtesy JHSGH.*

Town and Country: Eastern Connecticut

The Jews of Ellington held religious services for about seven years in one another's homes. Anna Maskel, granddaughter of Louis and Chaya Franklyn, two of Ellington's earliest Jewish settlers, recalls:

> *Among my most impressive, early childhood memories were the religious services held in a large living/dining room in my grandparents' home. I was awed by white prayer shawls and chanting of prayers I did not understand. I remember vividly the loose, yellow pages of tattered old prayer books held so reverently in work-worn hands.*

At the end of the summer of 1913, the members of the newly constituted congregation Knesseth Israel (Gathering of Israel) assembled to lay the cornerstone for their new communal home. The long-awaited building was finally completed at the end of the following summer; the total cost came to $1,500. Dorothy Cohen described the building's original interior and furnishings:

> *The synagogue was heated by a wood-burning potbellied stove. Kerosene lamps were set in wall brackets, and two chandeliers hung from the fourteen-foot-high ceiling. The walls had painted wood wainscoting, and the upper walls were covered by an embossed metal sheeting that was painted a cream color. There were plain wooden floors and oversized dome-capped windows. The women's area was sectioned off by a middle dividing wall containing a series of curtained moveable windows.*
>
> *The men's section contained all the religious articles, encased in a tall painted wood ark. The ark formerly stood on a two-foot-high stand raised by a narrow platform with two steps on each end. A prayer* bimah *(raised platform) stood in the center of the men's section. High-backed oak-stained kitchen-type chairs, some folding wooden benches and a few tables completed the furnishings.*

The members of the Knesseth Israel synagogue were proud of their simple clapboard house of worship, one of the first synagogues in the Connecticut River Valley. They were equally proud of the principles upon which the synagogue was founded.

The founding constitution of Congregation Knesseth Israel was authored by two local scholars, Samuel Levine and Louis Franklyn, who composed it in Hebrew rather than in Yiddish, the native language of most of the Jewish farmers, or in English. Both had settled in Ellington in 1904 and were active in the establishment of the organized Jewish community.

One interesting provision of the constitution proclaimed that any member who brought dishonor upon the community by violating its ethics and mores could be suspended from the fellowship. This particular provision betrays the Jewish farmers' concern with the way they presented themselves to the larger world that surrounded them. Although all of the Ellington Jews I interviewed spoke emphatically of their close friendships with many of their Christian neighbors, they seemed equally cognizant of their vulnerable position in a largely non-Jewish community.

Ellington's little white synagogue became the focal point of Jewish life. The fall festival of Sukkot held particular significance. At that season, they gathered together to celebrate the harvest, both in the synagogue and in the sukkot, small harvest huts, which they erected on their individual farms and dedicated to the fruits of their labors.

Though nominally Orthodox and traditional in practice, the Ellington synagogue attracted both observant and nonobservant Jews. Orthodox Jews joined Reform, Zionist, socialist and those with other beliefs to form a cohesive group. It is doubtful whether such a phenomenon would have been possible in a larger or less isolated Jewish community.

The hiring of a rabbi, even on a part-time basis, would have placed a great financial hardship on the tiny community. Beyond financial considerations, however, there may have been other barriers to the hiring of a rabbi who might have shattered the delicate balance between so many different kinds of Jews. A rabbi might have seemed overly authoritarian to the democratically inclined Jews of this community. A rabbi might not have understood that these Jews were as committed to the land as they were to learning, that they were cut of the same cloth as the *halutzim* (pioneers) struggling to survive in Palestine.

Rabbi Debra S. Cantor serves as the rabbi of Congregation B'nai Sholom, formerly in Newington, now located in West Hartford, Connecticut. She is a member of the first class to include women at the Jewish Theological Seminary in New York.

CHESTERFIELD: A SHTETL IN AMERICA

Micki Savin

My maternal grandparents, John and Sarah Kaplan, arrived in New York City from Russia in December 1897. Three years later, they purchased a farm in Chesterfield, Connecticut,

We lived in Norwich, about fifteen miles away, but I spent many, many happy days visiting my grandparents. I clearly remember their farm, the family, how they lived in this small farming community. With pleasure I recall swimming in Kosofski's delightful brook. Blueberrying in fragrant meadows. Grandpa's general store and dance hall. The austere little synagogue. I can never forget some of the residents. Isadore Savin, whom I married and with whom I had a forty-year love affair. Mama, my most unusual mother-in-law, and this community of hardworking Russian Jewish immigrants who forged another way of life for the generations that followed.

In the early 1890s, several years before I was born, Chesterfield, Connecticut, was a cluster of small farms, bisected by a single dirt road that rolled north-northwest out of the environs of New London, Connecticut. For nine miles, the road (now Route 85) passed through a sparsely populated rural landscape, then plummeted down a long hill, leveled out and, a mile farther, touched the Salem town line.

Between 1890 and 1895, several families came to Chesterfield under the baron's [de Hirsch] auspices but soon moved on to more profitable and easier avenues of success. There was a rapid turnover of properties. The thirty or so steadfast families who persisted and took root in Chesterfield endured great poverty. I knew many of them and their descendants: the Schneiders, Gruskins, Leviloffs, Cohens, Agranovitches and Polskys.

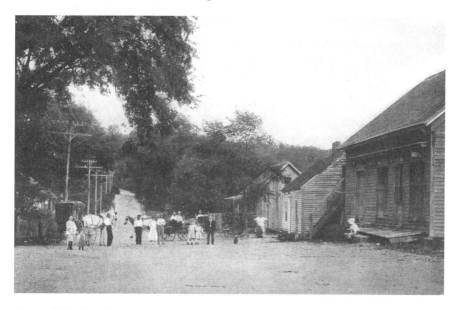

Chesterfield, 1910. *Courtesy Jon B. Chase.*

And they struggled. Alien to the land, alien to the language, alien to the customs, they created their own village, a shtetl, similar to those to which they were accustomed. There was a blacksmith, a cobbler, a Hebrew teacher, a synagogue, a bakery and a cemetery. Although the families had come from diverse locations in Russia, their shared culture formed a cohesive community among their Yankee neighbors.

The farms were meager, the soil tired from years of previous cultivation. Unfortunately, any knowledge of farming had not been a prerequisite for the people who settled on this land. Farming was slow and ungainful. The salt of human sweat seasoned the piles of hay stacked high in the fragrant meadows. It poured onto the long hills of potatoes, cabbage and fodder raised against a relentless winter. It froze as the men made their way to steamy barns on icy mornings. It stained their clothes, seared their lives as they unceasingly wrestled with the barren, stony soil of New England. Dairy farming was popular, and the Baron de Hirsch encouraged the farmers by building a creamery on Flanders Road. Here the farmers could sell their milk for a penny or two a quart to the New London Dairy. However, the cows, usually a herd consisting of a dozen animals, were of mediocre quality and did not produce adequately.

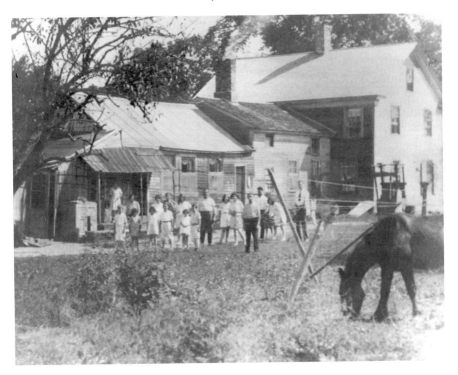

The Kaplan family homestead in Chesterfield. *Courtesy Nancy R. Savin.*

As the end of the century neared, circumstances improved. Some of the farmers began to take in paying guests. Called "pleasurefolk," they came from the teeming neighborhoods of New York City to escape the dreaded heat and to avoid the childhood diseases. Mumps, measles, chickenpox, poliomyelitis, whooping cough, scarlet fever, diphtheria—violent, rampant and uncontrolled—exacted a fatal toll.

For seven dollars a week, the boarders expected to gain twenty pounds a summer on the unpolluted air and the excellent and ample cuisine prepared by the farmers' wives. I remember my cousin Ethel telling me that she had seen my grandmother cooking on four wood-burning stoves simultaneously for the many guests staying at the farm. Corpulence was a symbol of success. It indicated that a person possessed enough money to buy food. Fancy accommodations were unimportant. People slept two

or three to a bed, often three beds to a room. They bathed in the brooks and, in the evenings, created their own entertainment. Someone played the piano. They danced and sang and kibitized.

The heyday of Chesterfield boarders probably lasted from 1895 to 1915, when the creamery closed. I remember my mother-in-law kept a few boarders, old friends, as late as 1930. They were different from earlier boarders. They rented one or two rooms for the summer, usually unoccupied spare bedrooms, with cooking privileges. This was an advantage for both the farmers and the visitors. From the host farmers they bought milk, eggs, butter, cheese, chicken, fresh vegetables. Peddlers drove into the farmers' yards to sell fruit, fish and fresh-baked goods. Mr. Miller sold meat, and my grandfather's store offered other supplies.

━━

Well pleased in Chesterfield, boarders enjoyed being in a comparable Jewish enclave, feasted each day on three whopping big meals, a generous teatime and a satisfying snack before going to bed. The following is a typical day's menu:

BREAKFAST 8:00 A.M.: Fruit, cereal, hot or cold; eggs, cooked to order, any style; herring, fried, plain or pickled; farmers cheese, blueberries or bananas, clotted cream; pancakes, French toast or coffee cake; bread, butter, jelly; pitchers of fresh milk, sweet cream, coffee, cocoa.

DINNER 12:30 P.M.: Appetizer such as chopped liver or fricassee; hot soup with accompaniments; roast meat or chicken; potatoes; noodle pudding; tzimmes (carrots and sweet potatoes), peas or string beans.

TEA 4:00 P.M.: Tea, cake, strudel, cookies, preserves.

SUPPER 6:00 P.M.: Cold soup: borscht [beet] or schav [sorrel]; fried fish or canned salmon; corn on the cob; blueberries, farmer cheese, clotted cream; sliced tomato, cucumbers; dessert, rice pudding; pitchers of fresh milk, sweet cream, coffee.

At bedtime there was always a snack lest anyone get hungry in the night. All one could eat. All dairy products homemade. All vegetables from the garden. All prepared on slow wood-fired stoves in the summer kitchens.

Excerpted from I Remember Chesterfield: A Memoir *(AuthorHouse 2005).*
See also the New England Hebrew Farmers of the Emanuel Society, Chesterfield
Connecticut: http://newenglandhebrewfarmers.org.

BETWEEN MARJORIE MORNINGSTAR AND DIRTY DANCING: GRAND LAKE LODGE

Marcia E. Tannenbaum

My father, Joe, and my mother, Sylvia, met at the Nevele Hotel in
Ellenville, New York, when they were in their teens. My father was a
busboy fresh off the farm; my mother was working in the hotel office.
From that summer on, my father wanted his own hotel, and in 1955 he
realized that dream when he purchased Liebmans' Grand Lake Lodge
on Williams Pond in Lebanon.

For twenty years, Grand Lake Lodge—located between the chicken
farms of Colchester and the little working-class town of Willimantic—was
the center of my family's life. Our year was divided between the season,
from Memorial Day to Labor Day, and not the season. During the rest of
the year, we lived in Norwich, eighteen miles from the hotel. There were
curfews and rules; I was a bookish girl who studied a lot, made honor roll
at Norwich Free Academy, was active in USY and NCSY and was serious
about school and life.

But in the summer, I was somewhere between Marjorie Morningstar
and Dirty Dancing. My teen summers were informed by the benign
neglect of my otherwise watchful parents. Like my older brother, Alan,
I was sent at the age of thirteen to live in the staff quarters. My brother
learned to smoke cigarettes, to play poker and to appreciate girls. I
learned to play ping-pong, among other skills, and to fend for myself.

Over the years, many of my nearly thirty first cousins worked at the
hotel. If you needed a job, you called Aunt Sylvia, and overnight you
became a waiter, a bellhop, a lifeguard, a counselor in the day camp.
Cousins and the children of old friends came from the Bronx, Philly,
Atlanta, even from California to earn money for school and to spend the
summer under what was assumed to be the watchful eye of Uncle Joe.

The casino and dining hall at Grand Lake Lodge.

For me, summer was about boys and romance, about late nights and tired mornings, about negotiating between being the boss's daughter and being one of the staff. The summer was about moonlit rides in a rowboat left unlocked by arrangement with the lifeguard, late-night drives into Willi (Willimantic) for food and flirtation.

From the time I was thirteen, I worked with my mother in the front office. I sold stamps for postcards, answered the phone, took reservations, typed the menus, showed people to their rooms. I learned to smile on cue. My least favorite task was accompanying her from table to table in the dining room, inquiring at each table about the food, the service, the weather. She was always grooming me to follow in her footsteps as the lady of the manor.

But I was drawn to my father's style. He was a take-no-prisoners kind of guy. His favorite expression, when asked why he had brought only his own dinner to the family table, was, "Every man for himself." This response was always delivered with a grin. He loved a good joke, a good cigar, a good Scotch.

The dining room was the center of the hotel in every way. Meals provided the rhythm of the day. I can still hear the loudspeaker, often in my own voice, declare, "Ladies and Gentlemen, the Main Dining Room is now open for Lunch/Dinner." FOOD—strictly kosher—was the point of it all, and there was lots of it. I grew up thinking that everyone ate like

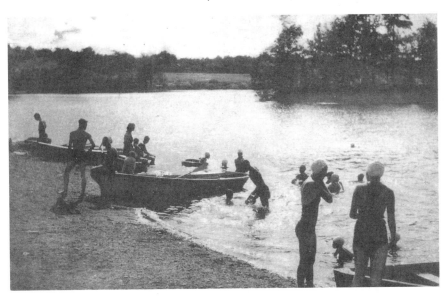

Dawn at Grand Lake Lodge.

my family. Even in the off-season, when the hotel was open for weekends or conferences, we had our own chef and such choices. Meals were also about the leisure time to sit and to enjoy every delicious opportunity.

The family sat at the family table near the swinging doors to the kitchen, where my father and brother spent most mealtimes cajoling temperamental chefs and otherwise running interference between the waiters and the kitchen staff.

The table contracted and expanded depending on the time of year. At any given meal, there would be the immediate family consisting of my mother and father, my brother and my paternal grandmother. Known as Grandma by one and all, she was surely the most colorful member of the family. She was a woman with an opinion about everything. She did a mean cha-cha and loved being the belle of the ball. Often there would be a salesman who had stopped by to pitch a new product and was invited to join us for lunch. Family friends, too, sometimes joined us for a meal or a day or two.

Best of all was late August, when family members came to the hotel. It was a rowdy crowd, and the expanded table overflowed with laughter. We swam together and rowed out on the lake to pick blueberries on an island. We took long walks on the main road or even longer walks on the dirt road into Colchester—always feeling safe.

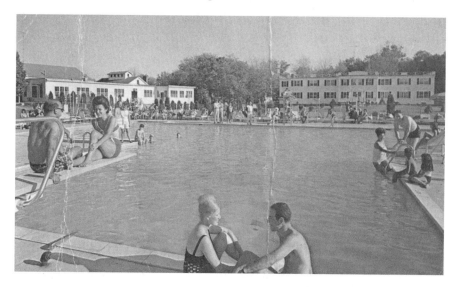

Grand Lake Lodge swimming pool. *Courtesy Rob Fader.*

Growing up, I competed not only with my brother for my parents' attention but also with the hotel. Now, so many years later, long after the 1975 fire that put my parents out of business, I appreciate how enriched I was by those years. Recently, my Tannenbaum cousins have been gathering for a summer weekend reminiscent of those special times inspired by those Grand Lake Lodge summers.

Wherever I go, I still hear: Tannenbaum? From Grand Lake Lodge? And I am so pleased that others remember warm summer days and sunsets at the lake, bar mitzvahs and weddings and weekends and shabbatons and friends gone by.

Marcia E. Tannenbaum lives in Worcester with a rescue beagle named Annie. Her father's law school diploma and bar admission certificate hang on the wall next to hers in her home.

Connecticut's Connection to the Holocaust

From Nazi German to Hartford:
One Family's Journey

Shira Springer

The Western Union telegram from Halsdorf, Germany, to Hartford, Connecticut, carried an urgent message. "Vater vereisst," it read. Literally translated, it meant, "Father has gone on a trip." But in January 1940, with the persecution of German Jews escalating, the telegram signaled desperate times ahead for the Katten family. The message was unsophisticated code telling relatives already in America that Salomon Katten, the sixty-nine-year-old family patriarch, had been taken to a concentration camp.

The devastating news complicated ongoing efforts to arrange safe passage to America for Salomon, his wife, Malchen, and their daughter, Gerda, my grandmother. While my grandmother risked her life confronting Gestapo officers and successfully negotiating Salomon's release from the concentration camp in late April 1940, my great-aunt Adele in Hartford worked tirelessly to obtain visas and steamship tickets. She left no lead unexplored.

When all other efforts had hopelessly stalled or failed, Adele contacted U.S. Senator John Danaher. Members of the Hartford Jewish community

told her to write the Connecticut politician because he was "someone who helps people."

Highly regarded by his Senate colleagues, Danaher was a devout Catholic, a Yale graduate and an isolationist. Despite a background far different from the Kattens, he was guided by his desire to "keep making the right choice, doing the right thing." He offered my family his contacts, the weight of his political position and unflagging support, though he thought these would be insufficient. But his political power proved the perfect complement to the persistent efforts of my great-aunt Adele and the determined risk-taking of my grandmother Gerda in Germany.

Coordinating strategies, they navigated the increasingly complex laws and arbitrary regulations trapping Jews inside Nazi Germany. Danaher first personally contacted the Visa Division at the State Department on behalf of my great-grandparents and my grandmother. And so began a harrowing, emotional journey from Halsdorf to Hartford for one family.

On July 16, 1940, Salomon, Malchen and Gerda were asked to visit the American consulate in Stuttgart to pick up visas. But they could not obtain visas until they presented proof of steamship tickets. Conversely, steamship companies were reluctant to book passengers who could not produce proof of exit visas. Many Jewish families waited years for appointments at the American consulate. If all the paperwork and ticket receipts were not in order, a second chance to collect visas might never come.

After several failed attempts to secure steamship tickets on the American President Lines, Adele informed the senator of her difficulties. "Possibly, if you would contact the American President Line, they would take an interest in our case and do everything possible to secure our tickets at once," wrote Adele. "We realize that there are a lot of people working on this same thing at the present time, but as every day counts now, I am asking you to see if there is anything that you can do for us."

The next day, a Western Union telegram arrived from Washington, D.C. It read: "Have today requested expedited action through local office American President Line. Will keep you advised. John A. Danaher."

The day before Salomon, Malchen and Gerda were supposed to visit the American consulate, Danaher received information from the American President Lines. He wrote an urgent telegram: "San Francisco

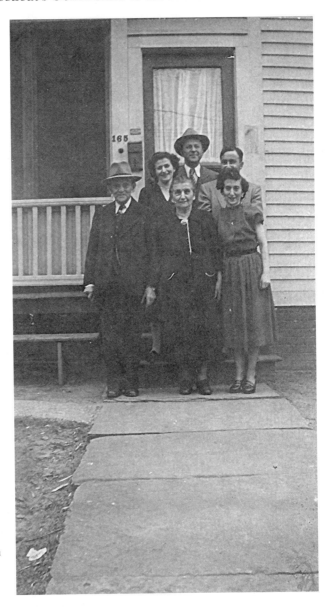

Reunited in Hartford. Salomon and Malchen Katten with their children (clockwise from left: Golde, Siegmund, Al and Gerda), 1950. *Courtesy Helene Springer.*

offers: Room 131 *Cleveland* sailing September 30 for Katten family." The American consulate quickly received word that my great-grandparents and grandmother had the necessary steamship tickets. But Salomon, Malchen and Gerda would never board the *President Cleveland* steamship. The revocation of citizenship for German Jews and the American quota system conspired to keep my family in Germany.

Salomon and Malchen fell into a preferred quota as parents of an American citizen, my great-uncle Siegmund, by virtue of his marriage to American-born Adele. My grandmother, then twenty-six, was too old to qualify as a dependent. Gerda was assigned a quota number of lesser priority that would delay the issuance of her visa and her eligibility for entrance into the United States. My family made a pragmatic decision about how immigration efforts would proceed, focusing on booking another passage for my great-grandparents before their exit visas expired and the Nazis rearrested Salomon. My grandmother Gerda would wait for a later opportunity.

By the end of September, Adele and Danaher secured passage for my great-grandparents aboard the October sailing of the *Nea Hallas*. It was uncertain whether Salomon and Malchen could complete the rigorous trip from Stuttgart and arrive in time for the steamship's departure. The *Nea Hallas* left Lisbon on October 4, 1940, but could not be contacted by radio for four days, until it sailed into international waters and cleared the threat of torpedoes. The fate of Salomon and Malchen was uncertain. Then, on October 8, my great-aunt Adele received the following cable relayed from the *Nea Hallas*: "Couple Katten proceeded New York."

Ever-changing American immigration requirements kept my grandmother's status in constant doubt. "We had hope that I would get out," said my grandmother. "I knew they were working hard in America." Danaher advised my family on how to improve Gerda's immigration standing. My grandmother received her visa on March 24, 1941. Her quota number, 24,158, was called in May. She traveled immediately to Portugal. In June 1941, my grandmother departed for New York on the *Siboney*, one of the last passenger ships to leave Europe during the war. Gerda reunited with her family at the Port of New York and then settled in Hartford with the rest of the Kattens. In July 1941, the Nazis officially closed all frontiers to Jews and began execution of the Final Solution.

Decades later, my family discovered that one of my father's friends and colleagues was Senator Danaher's grandson. My family had never met Senator Danaher. Now, Adele and Gerda had an opportunity to thank Danaher in person. A meeting was set for the first Sunday in June 1984. Danaher listened as my great-aunt Adele expressed her gratitude

The Katten/Kadden family reunion, circa 1990, in West Hartford. *Courtesy Helene Springer.*

and my grandmother recalled the danger she had escaped. The visit lasted no more than an hour. My family and the Danahers remain close to this day.

SHIRA SPRINGER grew up in Connecticut and graduated from Harvard University. She writes for the Boston Globe *and appears on NPR, CNN, MSNBC and ESPN to discuss her stories. See also "Saving the Kattens,"* Boston Globe Magazine, *July 13, 2003, http://cache.boston.com/globe/magazine/2003/0713/coverstory.htm.*

HIRAM BINGHAM IV:
HE DEFIED HIS GOVERNMENT TO SAVE LIVES

Robert Kim Bingham Sr.

My father needs to be remembered as Hiram Bingham IV because he grew up in the shadow of three previous Hiram Binghams. His great-grandfather and grandfather, Hirams I and II, were missionaries in the

143

Kingdom of Hawaii. Hiram Bingham II later continued his missionary work in the Gilbert Islands.

Hiram Bingham III, Harry's father, was an explorer who later became a Connecticut governor and United States senator. In 1911, while a professor at Yale, he uncovered the ruins at Machu Picchu in the Peruvian Andes.

As for Hiram "Harry" Bingham IV, he was officially recognized by the U.S. government as a "Distinguished American Diplomat" for his actions while serving as a U.S. vice-consul in charge of visas in Marseilles during 1940–41, after Hitler invaded France.

Around 1980, Tiffany Bingham Cunningham, then thirteen, interviewed her grandfather for a class project in Salem, Connecticut. He said:

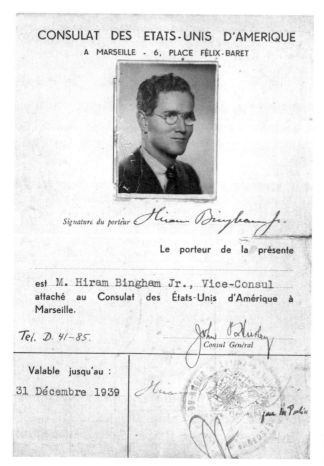

Courtesy of Eric Saul and the United States Holocaust Museum. The views and opinions expressed in this book and the context in which the images are used do not necessarily reflect the view or policy of, nor endorsement by, the United States Holocaust Memorial Museum.

We were transferred in 1937 to Marseille in France where there were a great many refugees from Nazi Germany trying to get visas to get to the United States, and part of my work was giving visas to these refugees…And we got rumors that the Germans were going to come down to southern France and would be there any time.

Although we were not in the war, most of our government was on the side of the Allies, the British and the French. But my [superior] said, "The Germans are going to win the war. Why should we do anything to offend them?"

He didn't want to give any visas to these Jewish people. So…I had to do as much as I could…The Germans had signed an agreement with the French that they could stay in that zone, but they must surrender any Germans that were there—any refugees—on demand, and they would then be sent back to concentration camps in Germany.

TIFFANY: What was the most important thing that you did for the Jews?

HIRAM: In a way, it was getting as many visas as I could to as many people. And we did help.

On September 16, 1940, the secretary of state, Harry's top boss, issued a cable to the American consulate in Vichy, France, denouncing Americans who were evading the laws of countries with which we maintained friendly relations. The message seems to be clearly directed at Harry and his accomplices, and to any other U.S. diplomats who might be out of line. The cable read: "This Government cannot, repeat, not countenance the activities as reported of Dr. Bohn [Frank Bohn of the American Federation of Labor Committee] and Mr. Fry [Varian Fry of the Emergency Rescue Committee] and other persons, however well meaning."

Harry was working underground with Fry and Bohn at the time. In fact, Harry had been hiding refugees in his diplomatic residence, including Lion Feuchtwanger, a formidable anti-Nazi author and visible target of Hitler, and conducting secret planning sessions in his home for ways to help refugees escape the Holocaust.

He not only helped save European artists and intellectuals who were on Hitler's most wanted list, like painter Marc Chagall and Nobel scientist Otto Meyeroff, but he also issued as many visas as he could to ordinary

refugees desperately seeking to escape the Nazis through Southern (Vichy) France. In 2002, Rabbi Joseph Schachter wrote to Harry's family:

I and my entire immediate family (six persons in all) had received the life-saving visas dated Feb. 7, 1941…I was just 10 years old at the time and do not remember any details other than a sense of relief that we were going to be able to escape the impending disaster having already had three "brushes" with the Gestapo—in Vienna in 1938 from which we fled to Belgium, and from Antwerp which we fled in May 1940, and in the Occupied portion of France from which we managed to make our way south.

Our parents are gone now, but there are quite a number of grandchildren and great-grandchildren scattered in many parts of the United States and Canada, and some of us now reside in Israel…To paraphrase my mother's saying: "When he reaches Paradise, he will find a multitude of greeters welcoming him and thanking him!"

In late 1941, Harry was reassigned to Lisbon and Buenos Aires. He resigned from the Foreign Service in 1945. By placing humanity above

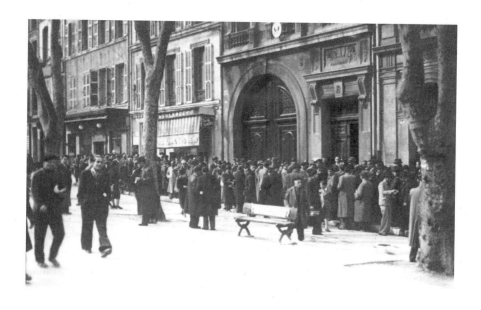

Refugees outside the American consulate in Marseilles. *Courtesy of Hiram Bingham and the U.S. Holocaust Memorial Museum.*

career, he had sealed his fate with the State Department. He brought his family to his ancestral home in Salem, Connecticut, where he and his wife, Rose, raised their eleven children until he died in 1988.

Harry was not a person to boast of his activities during the nightmare of the Holocaust. One time, he became ashen-faced with deep frowns when he painfully recalled long lines of refugees outside his Marseilles consulate window anxiously seeking visas. He said they were being "treated like cattle" and quickly changed the subject. His children did not know the extent of his rescue efforts until recent years, when old documents of that era were found in his Salem farmhouse and at various museums.

ROBERT KIM BINGHAM SR., *the author of* Courageous Dissent: How Harry Bingham Defied His Government to Save Lives, *coordinated the successful campaign to honor his father with a U.S. postage stamp. See also http://pages.cthome. net/WWIIHERO.*

A NEW LIFE IN NEW HAVEN

Sally Horwitz

After the Second World War, Poland and Eastern Europe were in complete chaos, and most of the Jews had to get out of the Russian-occupied zone. All of the existing confusion made it possible to cross over borders into the American zone of Occupied Germany and reach Bamberg.

Leon Glick, who married my sister Manya after the war, had some good friends in Bamberg who also hailed from Czestochowa, his hometown. One of these was Jacob Pepper, who, along with his wife, Helene, became very dear to me. The Peppers were the first of us to leave. An uncle of Helene, Jack Jacobowitz (of Jack's Bakery), had signed the required papers to bring them to "Nef Haven" early in 1948.

As soon as the Peppers settled themselves in New Haven, they started the process of getting papers for their hometown *landsleit* and included me in their efforts. Because I was single, I was separated from my sisters, Mary (Manya) and Frances (Franya). Not only was I alone on the ship, but I was also frightened. Finally, on July 15, 1949, at night, we were

standing on deck to see all the lights as we neared New York. Then we sighted that lady, holding high the torch, who was telling us, "You are safe; you are free; no one can harm you."

I spent the first few days and nights in this country at the Peppers', along with my sister, her husband and their baby, Esther. Not only did we meet many newcomers at their house, but also Helene soon began stuffing us with food we hadn't seen in about ten years. She kept all kinds of cheeses on the table, along with herring, sour cream and, of course, ice cream. It took some time until I realized that food would be there for the next day, and the next and the next.

The Peppers lived on Washington Avenue on the second floor. They had a great front porch, and it seemed that every refugee in town came to the Peppers'. Because the summer was so hot, everyone headed to the porch.

After about two weeks, my sister, her family and I moved into a single room of a second-floor flat on Button Street. Soon I was placed in a job with the Rosenberg Bakery on Legion Avenue. The Jewish Family Service put me there, knowing that I was multilingual and could handle shoppers of all backgrounds who came to Legion Avenue.

My work hours were late, especially on Thursday and Saturday nights. Mort Horwitz worked with his father next door in their dry goods store, Horwitz House. He volunteered to take me home. It had to be straight back because my brother-in-law, Leon, would be waiting for me and no nonsense.

Early on, I started going to night school but soon switched to day classes. All I wanted to do was learn English and become a U.S. citizen. Back in Bamberg, some young men tried to *stroshe* (threaten) me that I would never find a man in America and that I should get married before departing. They proved wrong. Within weeks, I was engaged to Mort and became a bride in less than a year. In my citizen classes, I had learned much of American history and wanted to see those places I studied. So, our honeymoon took us to New York, Philadelphia and Washington.

Mort's family was helpful in getting me to adjust. They visited me at every opportunity, especially at our first home at 45 Truman Street. There on Truman Street, I met a very nice group of young people my age. Now safe in our new country, marriages were taking place, babies were being born and families enlarged. It took a lot of *chutzpa* to have children after all that we had been through.

As more survivors arrived in New Haven and were introduced to the Peppers' hospitality, the home and porch became too small. Willie Rosenberg, Simon Klatzko, and Romek Filer began to organize the loosely knit group and arranged a meeting place at the Jewish Center. Jack Einbinder arranged for minimum dues for any survivor to join the *Farband* and gain access to its cemetery plots on Blake Street.

After Lew Lehrer arrived on the scene from Russia a few years later, he started working with and for the survivors' group for the newly immigrated Russians. His efforts took him to the Federation, and he joined with Rosenberg and Arthur Spiegel to form the official Holocaust Survivors Fellowship of Greater New Haven, which proved to be a very active and forceful organization. The major accomplishments included the building of the Holocaust Memorial in 1977, staging annual Yom Hashoah programs and the establishment of the Fortunoff Video Archives at Yale.

Taping the testimonies of the survivors was an idea hatched by Willie Rosenberg and Laurel Vlock, a prominent local TV show hostess. They

The Holocaust Memorial in New Haven, dedicated in 1977 to honor the Six Million. *Courtesy JHSNH.*

enlisted Dr. Dori Laub, a psychiatrist and himself a survivor, to sit by and analyze the subjects while Laurel Vlock questioned the participants so as to draw out their feelings and put them into words. I was among the first to appear. So successful was this opening to Holocaust testimonies that hundreds of area survivors were to follow with their own memories and, thereby, set an example for others all over the country.

Excerpted from the Jewish Historical Society of New Haven's The Jews of New Haven, *Vols. VI (1993) and VIII (2005).*

During the war, SALLY HORWITZ (SALA FINKELSTEIN) was forced to work as a slave laborer on a farm in Poland and was later imprisoned in two concentration camps. She and her husband have three children, seven grandchildren and eight great-grandchildren so far.

CONCLUSION

For more than 350 years, Jews have contributed to life in Connecticut, with the descendants of the German and Eastern European immigrants making up the bulk of the Connecticut Jewish population. Connecticut's Jewish communities have altered over time. People have moved from one neighborhood to another within the cities, from the farms to the cities, from the cities to the suburbs and from Connecticut to retirement communities in warmer regions. Synagogues and Jewish communal agencies have also changed, depending on the needs and locations of their populations.

Overall, Connecticut Jews today tend to live in the suburbs, to be well educated, to work in middle- to upper-middle-class occupations and to vote Democratic. Their religious identities and affiliations range from the most observant to those barely identifying as Jews by birth.

According to the 2007 *American Jewish Yearbook*, 64 percent of Jews living in Greater Westport have lived there for more than ten years. In Greater Hartford, the percentage is even higher: 85 percent. It is clear from these figures that Connecticut's motto—*Qui transtulit sustinet* (He who transplanted still sustains.)—speaks directly to the Connecticut Jewish experience.

BIBLIOGRAPHY

Cunningham, Janice, and David F. Ransom. *Back to the Land: Jewish Farms and Resorts in Connecticut, 1890–1945.* Hartford: Connecticut Historical Commission and the Jewish Historical Society of Greater Hartford, 1998.

Dalin, David G., and Jonathan Rosenbaum. *Making A Life, Building A Community.* New York: Holmes & Meier, 1997.

Donohue, Mary M., and Briann Greenfield. "A Life of the Land: Connecticut's Jewish Farmers." *Connecticut Jewish History* 4 (2010).

Gould, Sandra Innis. *The Jews, Their Origins, In America, In Connecticut.* Storrs, CT: Parousia Press, 1974.

Hoffman, Betty N. *Honoring the Past, Building the Future: The History of the Jewish Federation of Greater Hartford.* Hartford, CT: Jewish Historical Society of Greater Hartford, 2006.

———. *Jewish Hearts: A Study of Dynamic Ethnicity in the United States and the Soviet Union.* Albany, NY: SUNY Press, 2001.

Horton, Wesley W. "Annotated Debates of the 1818 Constitutional Convention." *Connecticut Bar Journal*, Special Vol. 65 (January 1991).

"Jewish Farmers in Connecticut." On-line exhibition of the Connecticut State Library, http://www.cslib.org/JewishFarm/index.htm.

Jewish Historical Society of Greater Hartford. *Connecticut Jewish History*. Vols. I, II, III. http://www.jhsgh.org.

Jewish Historical Society of New Haven. *Jews in New Haven*. 9 vols. http://jhsgnh.org/publications.aspx.

Koenig, Samuel. *An American Jewish Community: 50 Years: 1889–1939*. Stamford, CT: Stamford Jewish Historical Society, 1991.

Marcus, Jacob Rader. "Light on Early Connecticut Jewry." *American Jewish Archives Journal* (January 1949): 3–52.

Raider, Mark. "Jewish Immigrant Farmers in the Connecticut River Valley: The Rockville Settlement." http://www.ellingtonshul.org/ourcommunityshistory.htm.

Silverman, Rabbi Morris. *Hartford Jews, 1659–1970*. Hartford: Connecticut Historical Society, 1970.

Simon, Ken. Blog and images of Jewish resorts. http://www.simonpure.com/resorts-pix01.htm.

INDEX

A

ADAMAH, The Jewish
 Environmental Fellowship 83
Adath Israel (Middletown) 57
Ados Israel (Hartford) 39
aktsiyes 30, 31
anti-Semitism 17, 108
Apter, Jacob 71
Arbeiter Ring/Workman's Circle
 103
Auerbach, Beatrice Fox 38, 39, 45

B

bagels 107
Benjamin, Judah P. 102
Beth Israel 23, 24, 25, 26, 38, 46,
 62
Bingham IV, Hiram (Harry) 143
B'nai Shalom Synagogue
 (Waterbury) 94
Branford 14
Bridgeport 67, 77

C

Campner, Mayor Samuel 103
Carsen, Captain John 115
Chesterfield 123, 131
civil rights 21
Civil War 23, 39, 40, 68
Cohen, Wolff family 67
Colchester 122, 124, 135
Congregation Agudas Achim
 (Hebron) 124
Congregational Church 13, 22, 65
Congregation Beth Israel (South
 Norwalk) 69
Congregation Knesseth Israel
 (Gathering of Israel,
 Ellington) 129
Constitutional Convention of 1818
 22, 23
credit 29, 32, 120, 124

D

Danaher, Senator John 139
Danbury 67, 69, 85

Darien 67, 68
David the Jew 13, 21
de Hirsch, Baron Maurice 69, 121, 128, 131, 132
Democratic Party 56, 151
Drucker, Louis 68

E

Eastern European immigrants 15, 54, 74, 81, 90, 103, 115, 131
Easton 69
Elat Chayyim Center for Jewish Spirituality 83
Ellington 123, 126, 127

F

Fairfield 14, 65, 77, 105
farmers 91, 121
Featherweight Championship of the World 49
Fisher, Annie 41
food 125, 134, 136, 148
Fortunoff Video Archive 105, 149
Fox family 37

G

German-Jewish immigrants 14, 15, 17, 37, 89, 102, 115, 119
German-Jewish refugees 139, 147
Gomez, Moses and Esther Lopez 66
Grand Lake Lodge 135
Greenwich 66, 70

H

Hartford 14, 30, 32, 37, 41, 43
Hayes family 66
Hebrew free loan societies 30
hevrot gemilut hasadim 30
Holocaust 18, 58, 117, 124, 139, 144, 147

Holocaust Memorial (New Haven) 105, 149
Holtz family 39
Hooker, Reverend Thomas 13, 22

I

Immigration Restriction Acts 17

J

Jewish Agricultural Society (JAS) 122, 127, 128
Jewish Family Services 18, 61
Jewish Working Girls Vacation Society 80
Judaica 58, 59, 60, 105

K

Kaplan, Louis 47
Kaufman, Rabbi Ahron 97
Kruger's Juvenile Furniture 110

L

Lake Waubeeka 85
Lebanon 122, 135
Lender family 107
Levy, Moses 65
Lieberman, Joseph I. 19
Litchfield County 70, 74
Little Palestine 70, 124

M

Manchester 50
Marlow, George 50
Meriden 39, 47
Middletown 57
midwife's ledger 106
Milford 125
Mishkan Israel 23, 24, 27, 102
Monroe 69
Moodus 125
Mount Sinai Hospital 32, 33

N

Nathan, Robert Weeks 67
Ner Tormid, Jewish firefighters 86
New Britain 30, 54
New Canaan 68
New Haven 14, 15, 30, 101, 147
New London 115, 120, 124
Newtown 69, 124
Nones, Joseph B. 66
Norwalk 14, 67
Norwich 119, 124, 131, 135

O

Oak Street/Legion Avenue 148
Ocean Beach 116
Ocean Sea Grill 80
Old Lyme 125

P

Pinkas of 1905 128
Pleasure Beach 79
pogroms 15, 103

R

Redding 69
Revolutionary War refugees 13, 66
Ribicoff, Abraham A. 19, 54
Rockville 128
Roland, Governor John 95
Rosenthal, Selma B. 106
Russian-Jewish immigrants 120
Russian-Jewish refugees 18, 105,
 110, 119, 149

S

Seaside Park 78
Sephardim 13, 65, 98, 115
Shapiro family 57
Shomrim 86

Simsbury 62
Somers 123
Sons of Jacob (Torrington) 72
Stamford 14, 65, 69, 74, 76
Stiles, President Ezra 101
summer shuls 117, 125
summer visitors 125, 133, 135

T

Tannenbaum family 135
Temple Israel (Waterbury) 90
Torah Umesorah 95
Torrington 70
Trube, Andris 65

V

Vernon 123

W

Waterbury 30, 89
Willimantic 124, 135, 136
Wilton 69

Y

Yale 101, 140
Yantic 119, 120
Yeshiva Ateres Shmuel
 Yeshiva K'tana, Mesivta, Kollel
 97
Young People's Socialist League
 (YPSL), 104

Z

Zionism 57, 91, 118, 119, 121, 130

About the Editor

Betty N. Hoffman, PhD (anthropology), has conducted oral histories in and written extensively about the Greater Hartford Jewish community for many years. Her varied academic career includes teaching anthropology, social science research methods and English as a second language, as well as academic and business writing at various local universities and businesses. She is currently president of the New England Association of Oral History. Her most recent project was interviewing several of the informants and writing the script for the documentary film *Pride, Honor and Courage: Jewish Women Remember World War II* (JHSGH 2009).

Dr. Hoffman's publications include: *Jewish Hearts: A Study in Dynamic Ethnicity in the United States and the Soviet Union* (SUNY Press, 2001); "Witness to War: 1941–1945: The Soviet Jewish Experience," *Connecticut Jewish History* (JHSGH, 2001; Bruce M. Stave, ed.); *Honoring the Past: Building the Future: The History of the Jewish Federation of Greater Hartford* (JHSGH, 2007); *Jewish West Hartford: From City to Suburb* (History Press, 2007); and *Liberation: Stories of Survival from the Holocaust* (Enslow, in press).

Visit us at

www.historypress.net